MW00575870

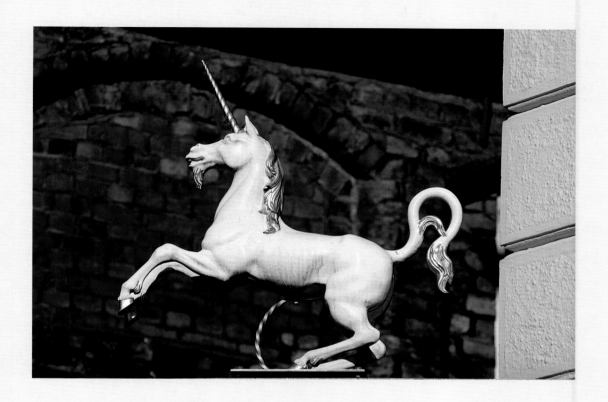

Journey through

LOWER SAXONY

Photos by
Ernst Wrba

Text by
Georg Schwikart

Stürtz

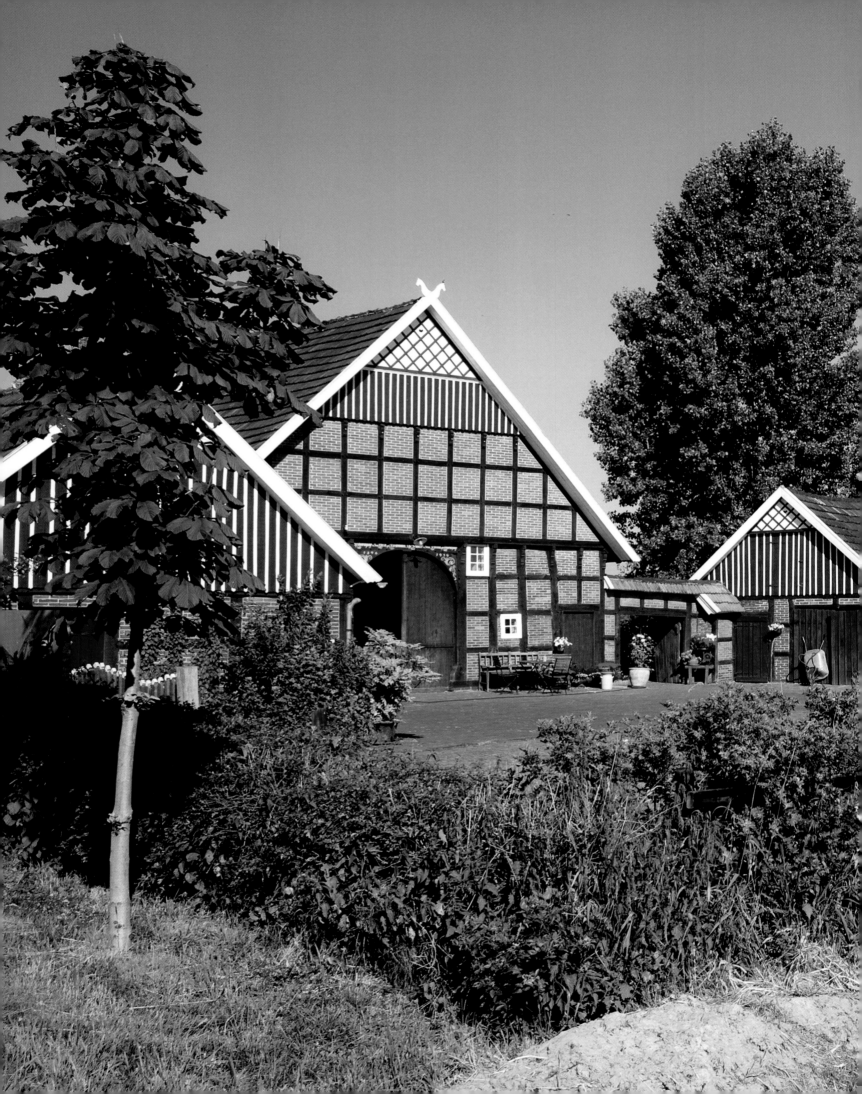

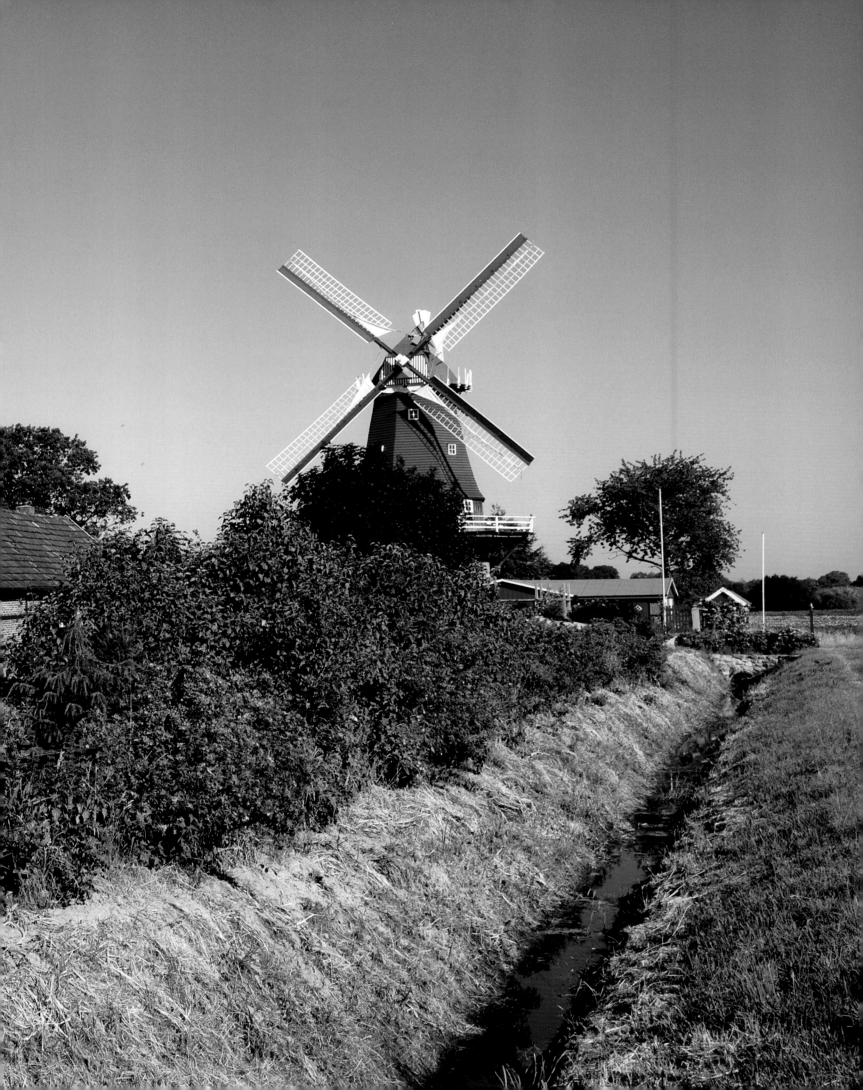

First page:
This unicorn adorns the facade of the oldest chemist's shop in the centre of Lüneburg.

Previous page:
Farm and Everdings Mühle in Groß-Mimmelage in the Artland north of

Osnabrück. The lavishly restored smock mill also doubles as a registry office for wedding ceremonies.

Below:
Einbeck is characterised by its over one hundred and fifty late medieval, half-timbered houses.

The beer which has been brewed here for centuries was the first bock beer in the land.

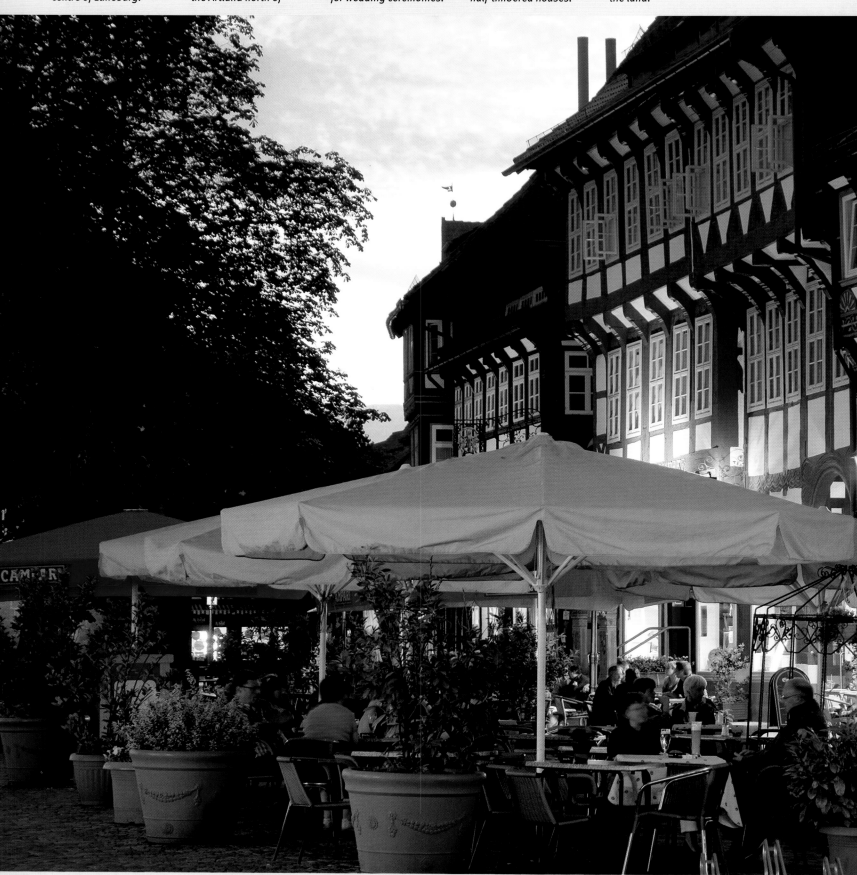

8

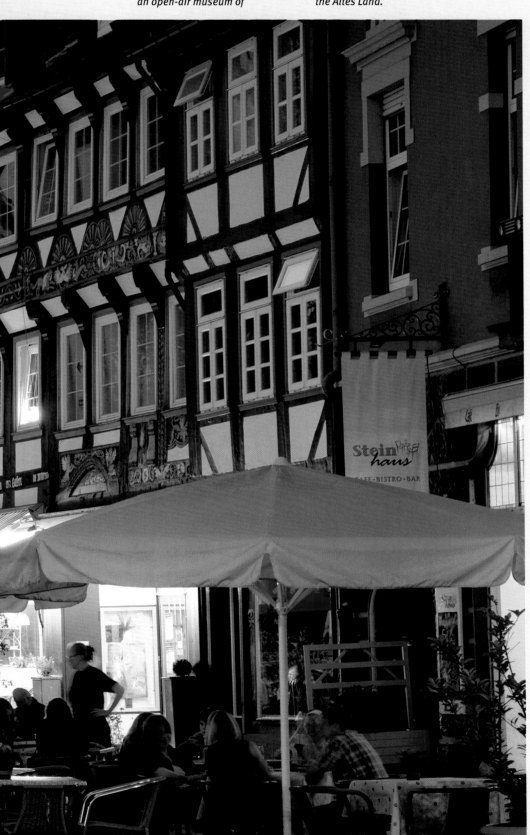

Page 10/11:
The island on Burggraben in the old Hanseatic city of Stade has been turned into an open-air museum of historic farmhouses. This building from 1733 comes from Huttfleth in the Altes Land.

Contents

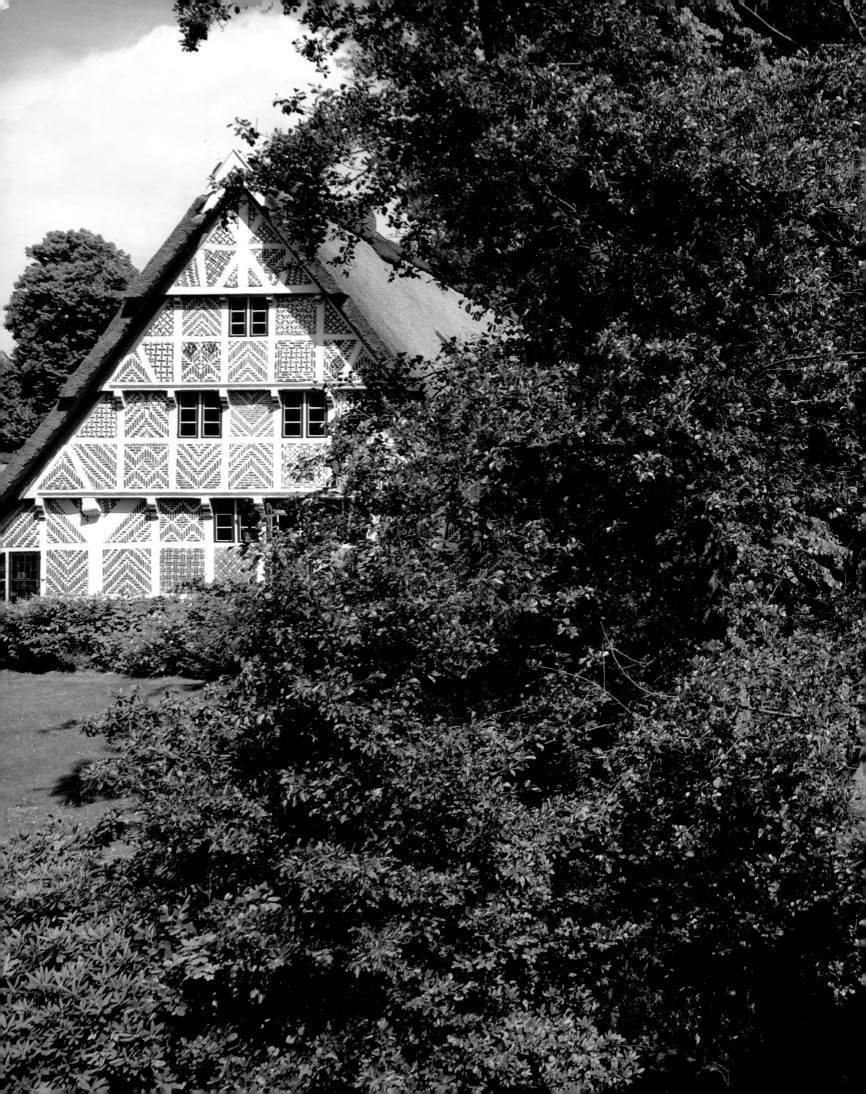

Neither palm trees nor caviar – Lower Saxony

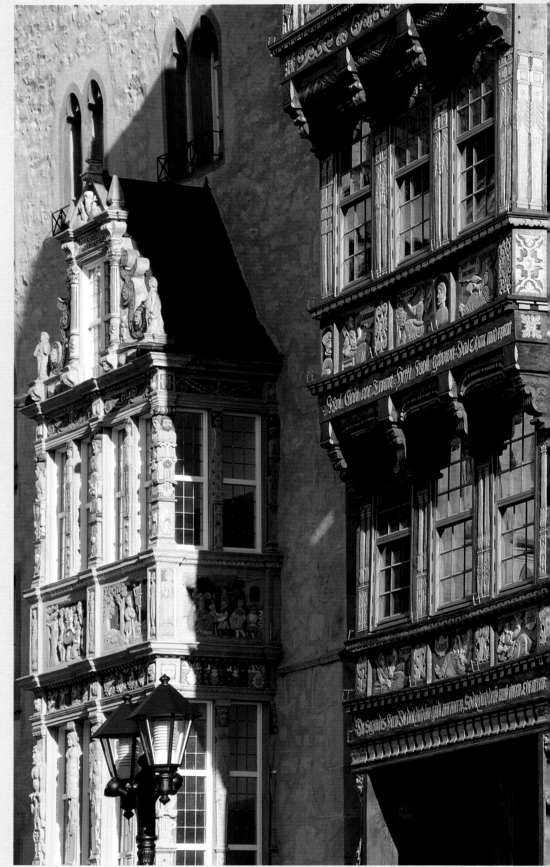

Following extensive reconstruction in the 1980s, the historic market place in Hildesheim is now once again complete with its Renaissance guild halls.

If you want palm trees and caviar, then one of the last places to look is Lower Saxony up in the north of Germany. Or at least that's the essence of a humorous but slightly sarcastic rhyme penned by one-time Hanoverian poet Julie »Julchen« Schrader (1881–1939). (»Kennst du das Land, wo keine Palmen wachsen? / Kein Kaviar …? 'S ist Niedersachsen!«). Palms or not, Lower Saxony still has plenty to offer. The second-largest federal state in Germany (after Bavaria) covers an impressive 47,600 square kilometres (18,380 square miles), from the North Sea coast in the north to the Harz Mountains in the south. The federal state of Bremen, comprising the city of Bremen and harbour at Bremerhaven, forms a small enclave bang in the middle of it all. Four rivers run through it: the Ems, Weser, Aller and Elbe. Three quarters of the countryside make up the Norddeutsche Tiefebene or North German Plains, with the south providing the hills of the Niedersächsisches Bergland. At 971 metres (3,186 feet) above sea level, the Wurmberg in the Harz is the highest mountain in Lower Saxony; its lowest point is a basin near Freepsum in East Frisia, two and a half metres (eight feet) below sea level. Of its almost eight million inhabitants, about half of them live in the metropolitan area of Hannover / Braunschweig / Göttingen / Wolfsburg; this is counterbalanced by huge expanses of rural, structurally weak countryside in the northeast and west of the state, such as the Lüneburger Heide (Lüneburg Heath) and the Emsland.

It's said that the purest German is spoken in the region of Hannover and Braunschweig (Brunswick). In contrast you can also hear plenty of regional patois; both Low German (*Plattdeutsch*) and Dutch are official languages here. Over half of the Lower Saxons belong to the Protestant church which has its headquarters in Hannover. 17.7 percent of the popula-

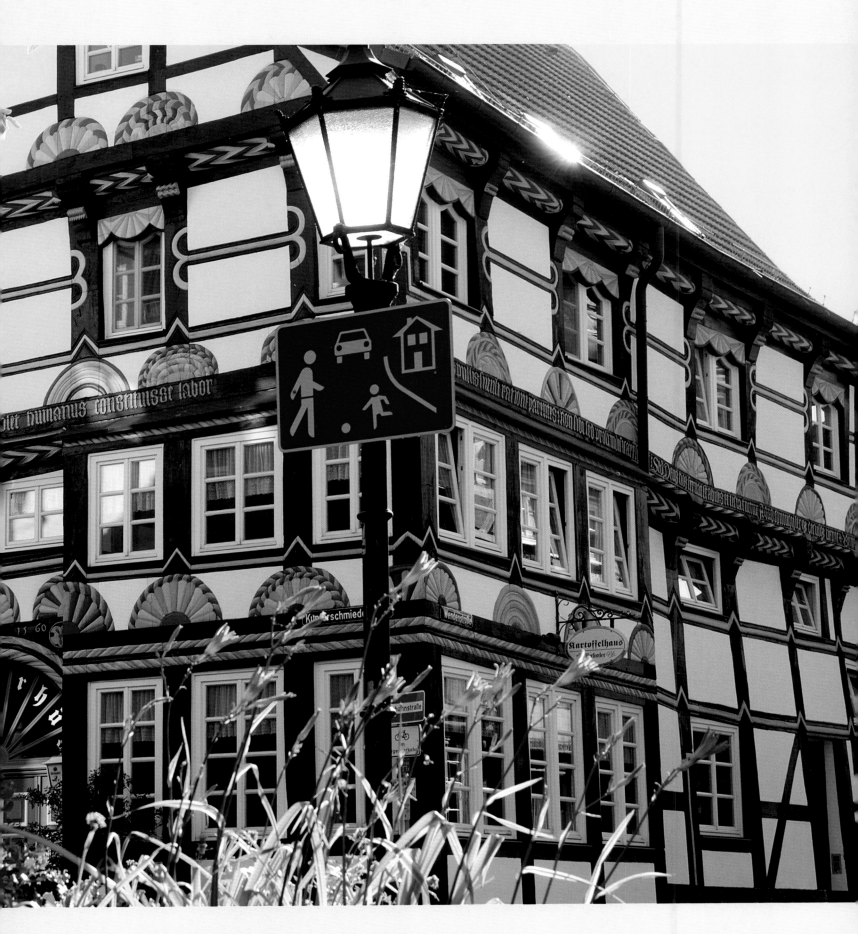

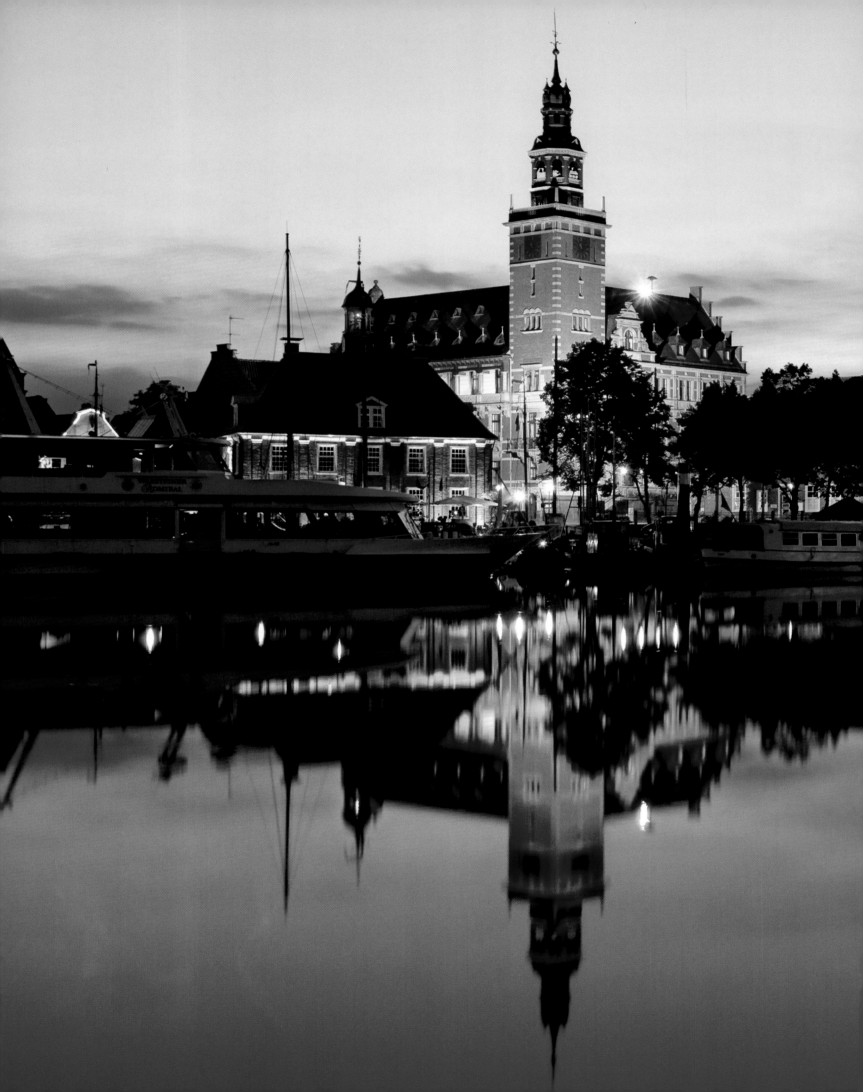

From the North Coast to the Oldenburger Münsterland

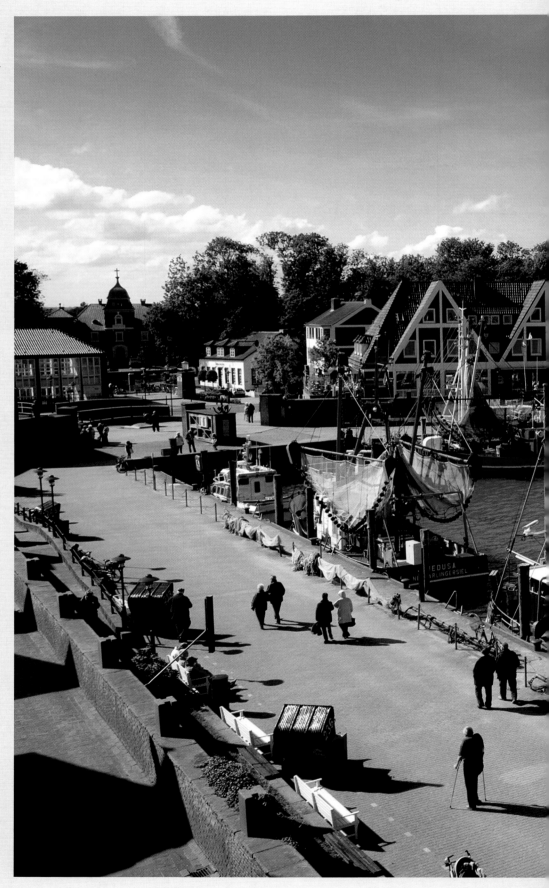

The North Sea spa of Neuharlingersiel is right on the coast. It boasts one of the most beautiful fishing harbours in East Frisia, its fleet of cutters still very much active.

The northwest, where the German mainland comes to an abrupt end, is one of the most popular holiday destinations in the country. This is East Frisia, with its islands which line the coast like a string of pearls. Sun, sand and the Wadden Sea draw thousands of holiday-makers here each year. The inland flats are paradise for cyclists; canoeists can happily paddle their way around East Frisia and on rainy days there are plenty of cultural gems waiting to be explored.

South of East Frisia is the Emsland with its beautiful riverine countryside. The area used to be the poorhouse of Germany as practically the only way of making a living was to cut peat off the moors. The region now boasts 1.5 million overnight stays a year. In the north between Haren and the shipyard town of Papenburg canals, locks, bascule and lifting bridges regulate the idle flow of the River Ems. In the hills of the Hümmling the late baroque palace of Schloss Clemenswerth with its Emsland museum on the eastern edge of Sögel is worth a trip. There are megalithic graves on the Hünengräberstraße to investigate. The Bourtanger Moor west of the Ems was once the largest area of moorland in Western Europe and today still has an area of 200 square kilometres (77 square miles). Osnabrück, the third-largest town in Lower Saxony, is packed with impressive historic buildings from Romanesque to Jugendstil. The Oldenburger Münsterland offers plenty of opportunities for good days out or relaxing weekend breaks. The water sports arena of Dümmer near Diepholz is surrounded by the hilly woodlands of the Dammer Bergen. Nature lovers are enthused by the skerries of the Thülsfelder Talsperre. And for cyclists there's a box stop route which starts and ends in Cloppenburg, taking the most energetic on a trip through 306 glorious kilometres (190 miles) of the Oldenburger Münsterland.

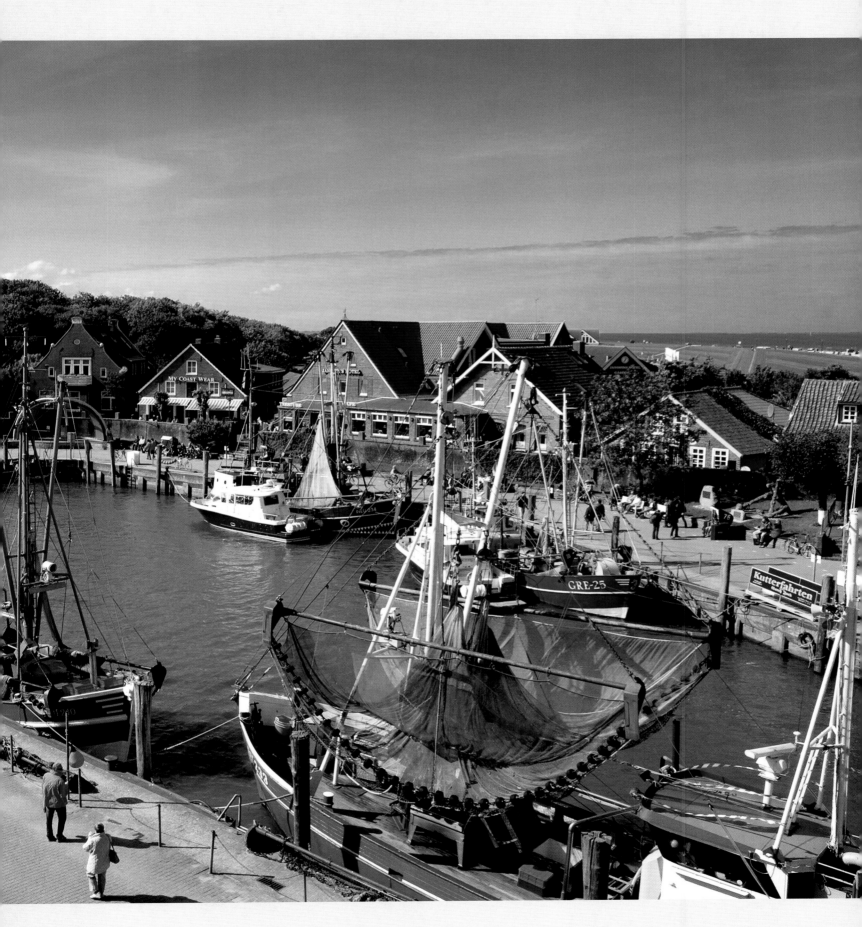

Below:

The museum harbour in
Carolinensiel. The harbour
is over 250 years old
and was one of the most
important ports of call
during the grand age of

sailing on what is now
the coast of Lower Saxony.
Part of the museum is
reserved for classic ships
and their painstakingly
crafted replicas.

Right:

The museum harbour in
Carolinensiel provides an
appropriate setting for the
four exhibition buildings

of the harbour museum:
the Groot Hus, captain's
cottage, old parsonage
and lifeboat shelter.

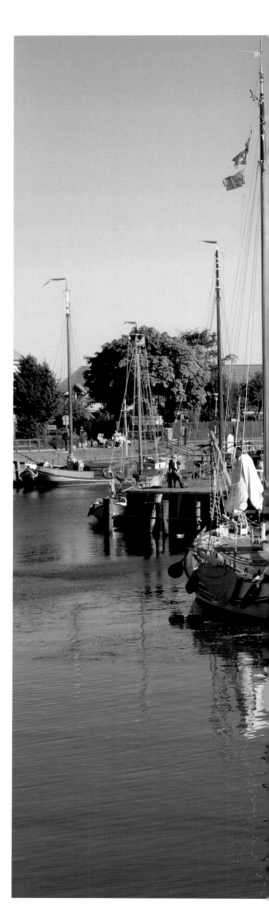

Above:

With its romantic array of
old fishermen's cottages,
the tiny yet picturesque

harbour of Greetsiel is
one of the best preserved
Siele in East Frisia.

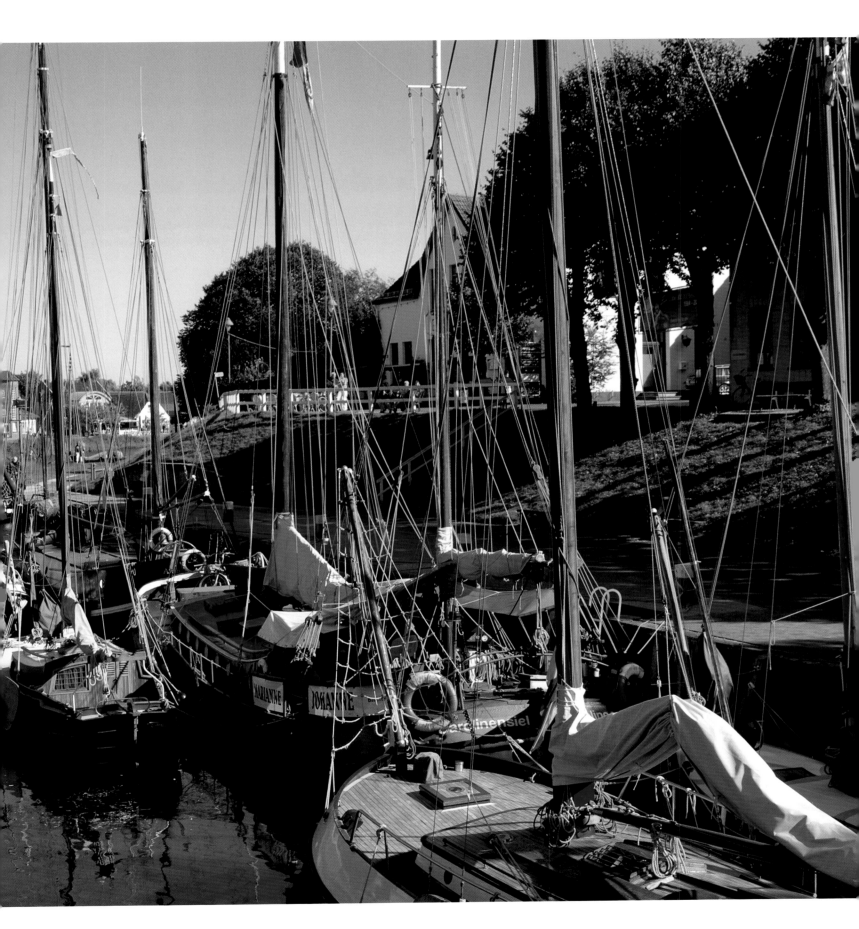

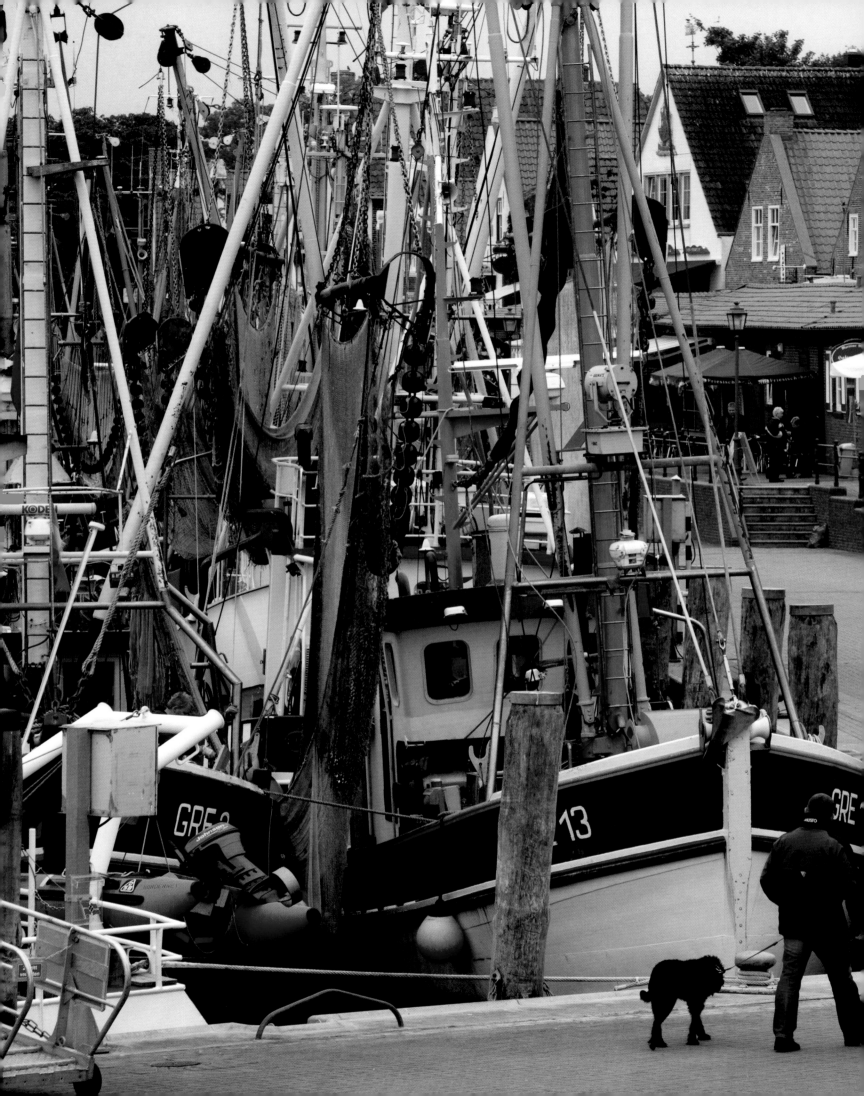

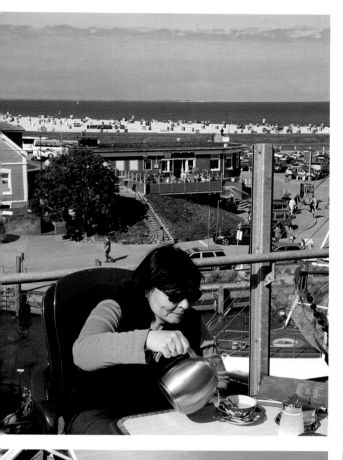

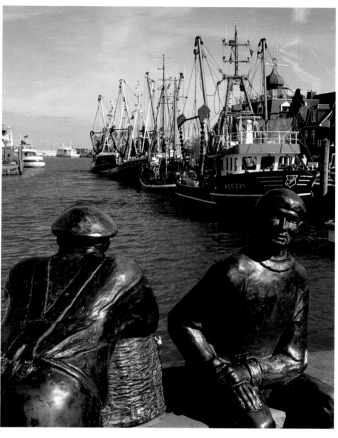

Far left:
East Frisian tea tastes even better sipped outside in a gentle sea breeze! Here, a visitor enjoys a good cuppa at the Störmhus café and restaurant in Neuharlingersiel.

Left:
These bronze sculptures of two fishermen in the harbour at Neuharlingersiel are by artist Hans-Christian Petersen (1947) from Esens. His father Wilhelm Petersen was the man behind Germany's famous Mecki, a series of children's books about a hedgehog from the 1950s.*

Left and far left:
Young and old soaking up the warm sunshine in the harbour at Neuharlingersiel.

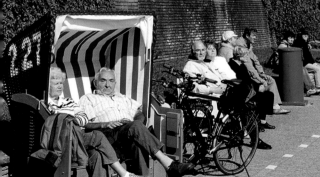

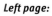

Left page:
The colourful cutters in the harbour are one of the most popular photographic motifs in Greetsiel.

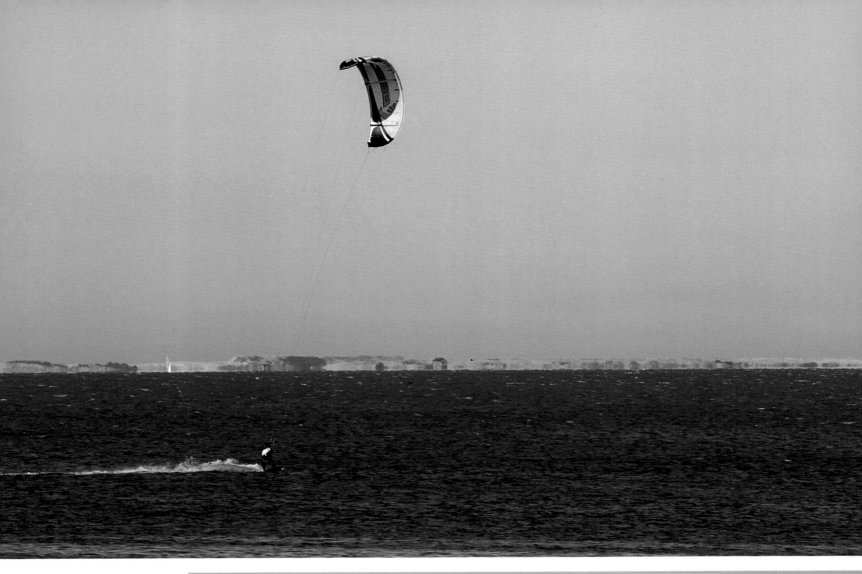

The North Sea spa of Carolinensiel-Harlesiel provides plenty of opportunity for some fun seaside activities. You can test the strength of the sea breeze kite surfing or, if you prefer to keep your feet on dry land, simply flying a kite. In the background you can just about make out the lighthouse and Westturm youth hostel on Wangerooge.

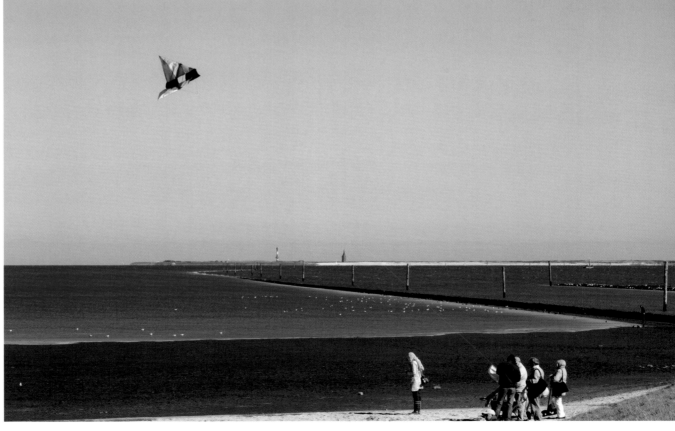

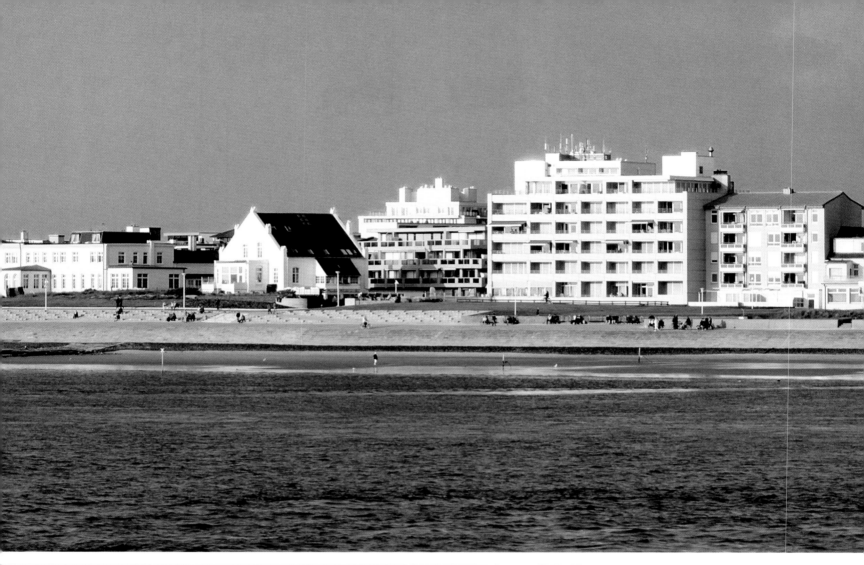

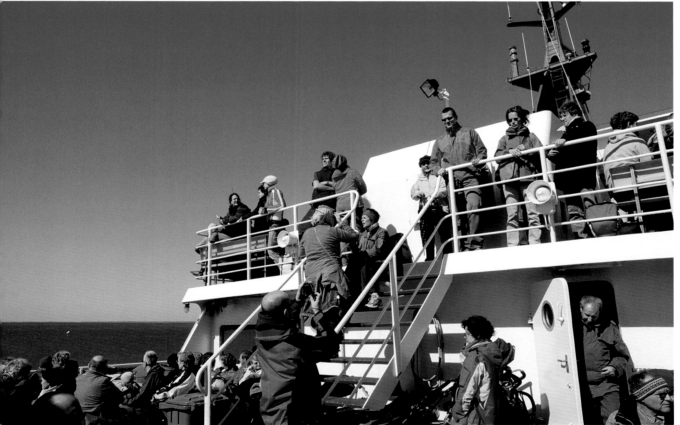

Above:
Westbadestrand or west beach on Norderney. Norderney was made the first royal Prussian seaside resort on the North Sea Coast as long ago as in 1797.

Left:
For many the crossing to one of the islands is an experience in itself. It's great to get out on deck and be buffeted by the fresh sea breeze –especially if the sea's calm and the sun's shining!

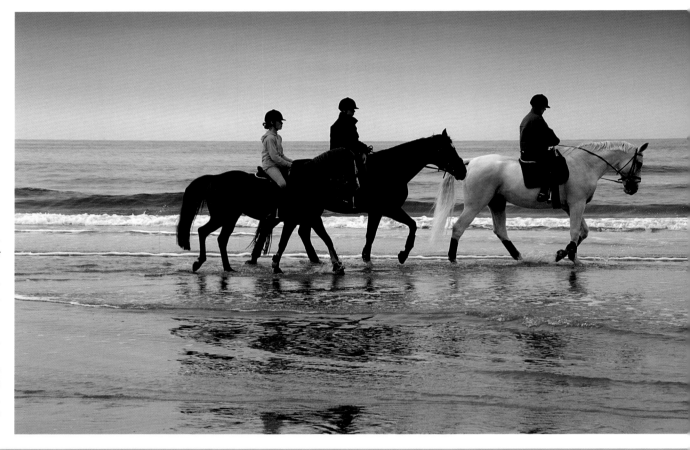

Right:
Riders on the beach of Norderney. Hiking, sailing, cycling, golf: the island has it all – and glorious seaside scenery to boot.

Below:
On the beach on Spiekeroog. The East Frisian Isles were formed around 5,000 years ago from sand banks whipped up by the wind.

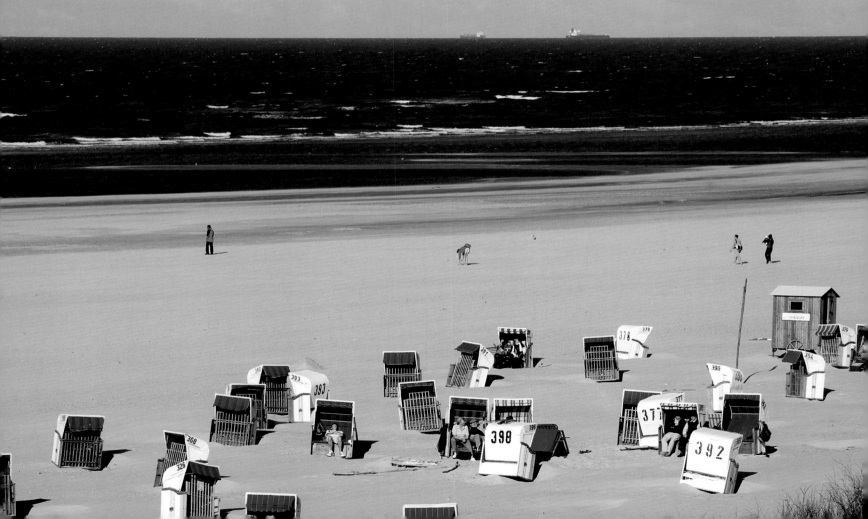

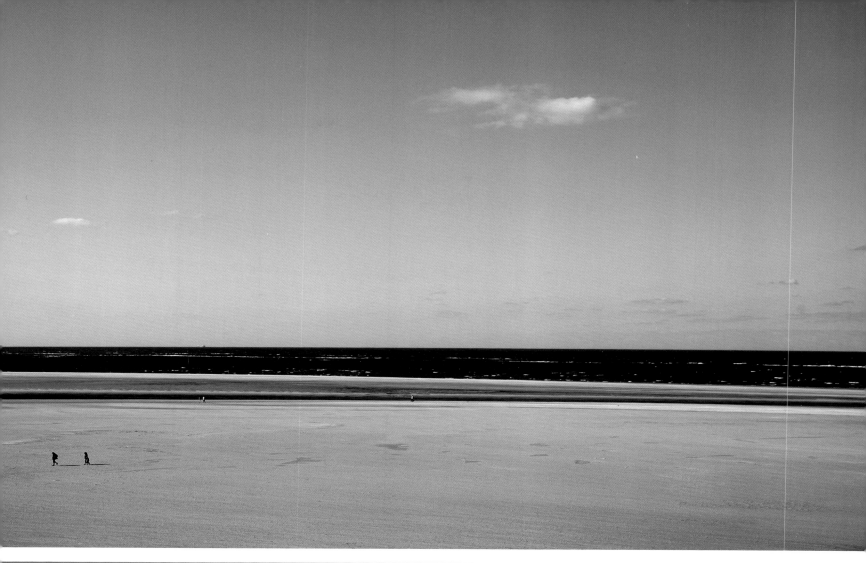

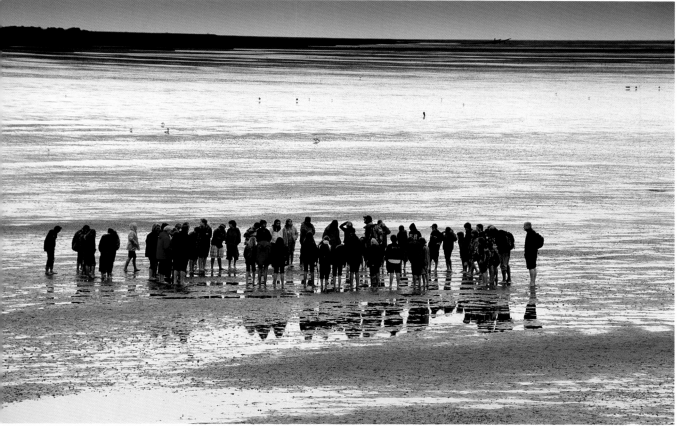

Above:
An endless horizon of sky, sea and sand: views like this are plentiful on the island of Spiekeroog.

Left:
In the Watt or Wadden Sea near Norderney this group listens carefully to their guide. And they have also taken good advice in view of the weather – which, as the saying goes here, is never bad; you just have to wear the right clothing!

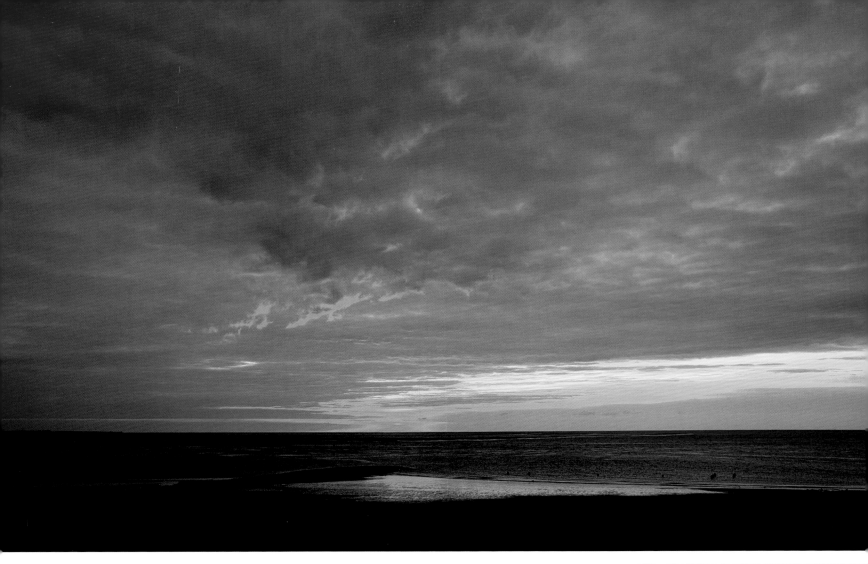

Above:
»The sea was my only company – and I have never had better«, Heinrich Heine wrote in 1826 of Norderney. Spectacular sunsets like these are a delight ...

Right:
... and equally enjoyable viewed from the deck of one of the many beach bars, perhaps with a delicious plate of Norderney seaside ham in front of you.

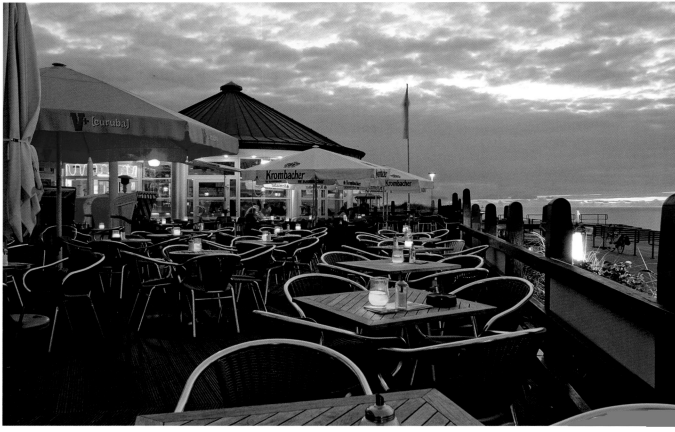

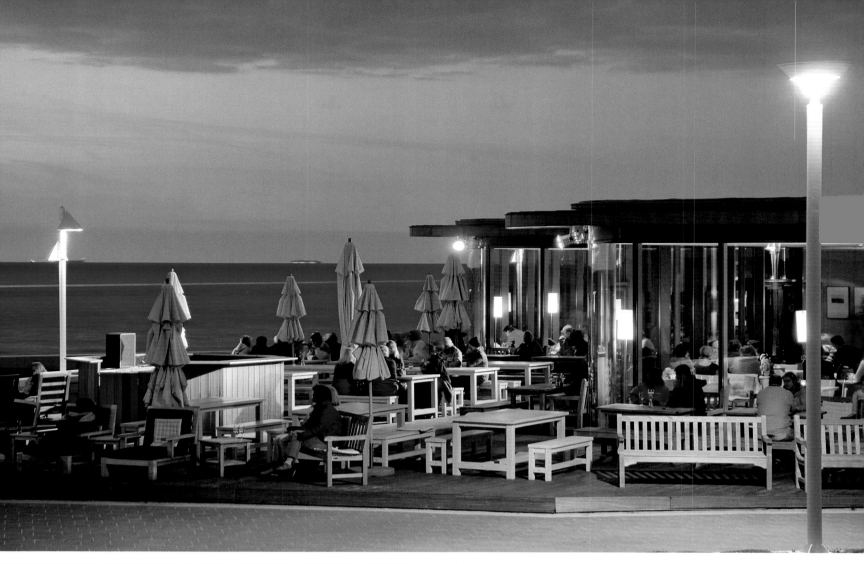

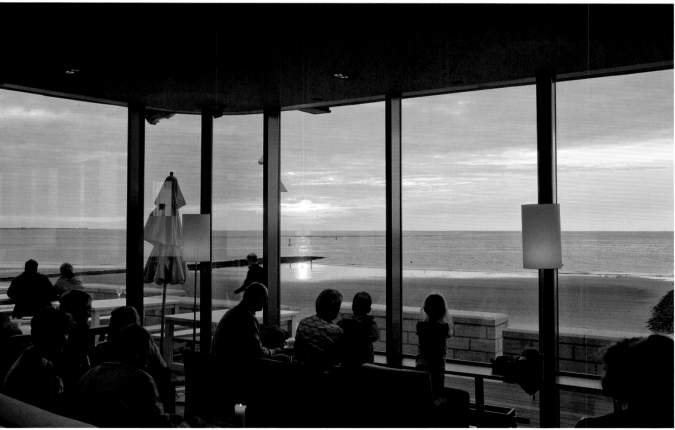

The Milchbar on the beach of Norderney in romantic mode. Theodor Fontane spent several weeks on the island in 1882 and 1883, writing »To spend three, four hours of an afternoon walking along or sitting on the beach is a delight. This is heightened by the fact that I like the local populace ... I cannot hold it against them that they charge a good price for their air et cetera.«

Below:
The centre of Norderney with the Inselhotel and pavement café. The North Sea resort has

four beaches. Over 400,000 visitors and spa guests come here each year.

Top right:
Square in front of the Conversationshaus, the pump house of Norderney

(left). It was erected in 1840 in the neoclassical style on Kurplatz in the centre of town.

Centre rig
Norderney has mo
cottages from the Bied

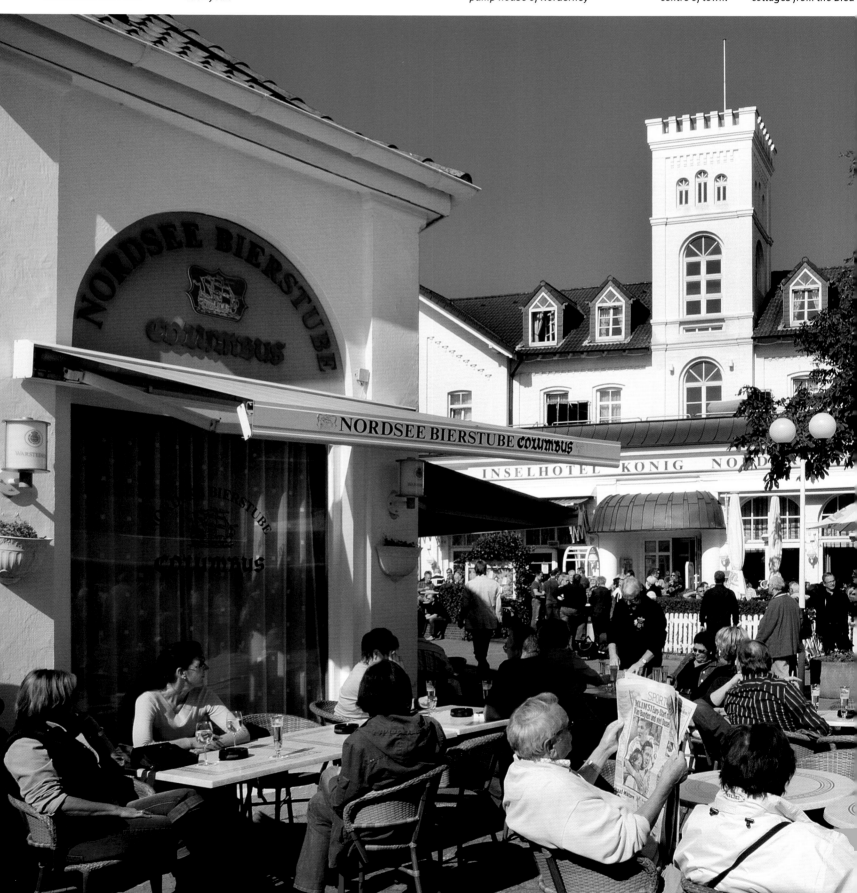

meier period and other historic 19th century dwellings to admire.

Bottom right:
Norderney has the only windmill in the East Frisia Isles. It was put up in 1862 and named Selden Rüst (barely idle); it now keeps busy as a stylish restaurant.

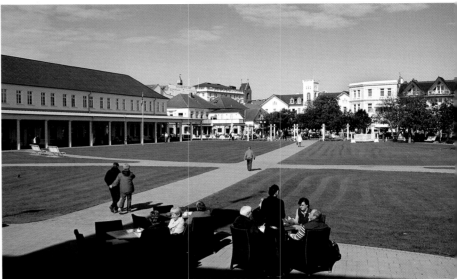

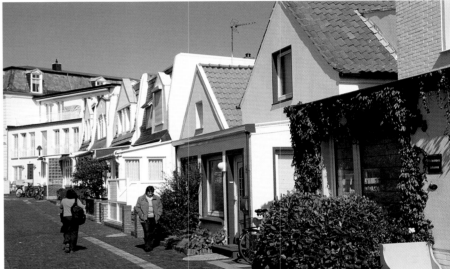

Between headland and heathland – East Frisia

In the extreme northwest of Germany, between headland and heathland, is a region whose name in all other parts of Germany is synonymous with all kinds of comical and often unflattering anomalies: East Frisia. This flat land on the coast covers a good 300 square kilometres (116 square miles) and includes the East Frisian Isles from Borkum to Spiekeroog. The Meerbusen Dollart divides the Dutch (West) Friesland from the German Ostfriesland. The vast moors in the south of the region have long cut the East Frisian peninsular off from the mainland and allowed it to undergo its own autonomous development. This rather bleak part of Germany is marked by centuries of battles with the flood tides of the North Sea. People began erecting wharfs and dykes here around one thousand years ago to protect themselves from the angry waves. Time and again, however, storm tides cost thousands of lives, with the last catastrophic floods those of Christmas 1717 and February 1825.

It's said that the East Frisians are a confident lot. Up until the 13th century they convened at the Upstalsboom, a medieval place of assembly near Aurich, to administer justice and pass resolutions. They manifested their freedom in hefty renditions of »Eala Frya Fresena!«, a slogan which still adorns the East Frisian coat of arms as »Stand up, you free Frisians!« The equally rousing reply – in East Frisian Low German, of course – is »Lever dood as Slaav!« or »Rather dead than a slave!«

Besides farming and fishing the towns lived off maritime trade. In c. 1600 the port at Emden was one of the most important in Northern Europe. In c. 1770 East Frisia had about 100,000 inhabitants. Some things were late to come to the region, such as the Industrial Revolution, for example. This may have prompted writer Ernst Moritz Arndt (1769–1860) to issue the following, rather scathing verdict on the Frisians. »They are typical in that they try to defend their custom, manner and ways from foreign infiltration with great jealousy and close unity. Through this unity amongst themselves and their isolation and reticence to anything foreign, strangers do not only consider the Frisian proud, intransigent and obstinate but probably also dim and intellectually limited.« Despite this, every year many thousands of visitors travel north to join the 465,000 East Frisians in their wide expanses of peaceful and relatively sparsely populated countryside. Guests welcome the green meadows and brilliant yellow fields of rape, the cycling paths and river bank trails, castles, windmills and lighthouses – and of course the natural spectacle of the Wattenmeer or Wadden Sea.

The local greeting here is »Moin«, not an abbreviation of »Guten Morgen« or »Good morning«, as you might expect, but rather »Have a nice day« – which is why it's used all day long, even at midnight. A good half of the East Frisians still speak the local East Frisia dialect.

Passionate tea drinkers

The East Frisians are passionate about tea. The average East Frisian drinks about 2.5 kilograms (5.5 pounds) of tea a year, ten times as much as the average German. The locals got to know and love tea through their Dutch and British neighbours in the 17th century – especially if it had a shot of rum in it. The drink comes with a little ceremony: first of all you put a lump of candied sugar or a *Kluntje* in your fine bone teacup, then you pour very hot tea over it until the sugar cracks and finally you top it up with *Room* – not rum but cream. Or sometimes both. On no account must the brew be stirred! Three cups are the standard ration in East Frisia; afterwards, movements are made towards the door. If you're more of a coffee person, you'd better bring your own Thermos …

East Frisia's most famous personalities include the 1908 Nobel Prize for Literature winner Rudolf Eucken (1846–1926), philosopher Hermann Lübbe (*1926) and journalist and publisher Henri Nannen (1913–1996). East Frisian clichés have provided comedian Karl Dall (*1941) with plenty of material – as they have the nationally famous Otto Waalkes (*1948). Their brand of humour is, however, rather more complex than most of the flat jokes (excuse the pun) told about the locals which paint them as simple and slightly idiotic. Mind you, there is one which is quite good. »Why don't the East Frisians laugh at jokes about East Frisia?« – »Because they already know them all«.

Eala frya Fresena

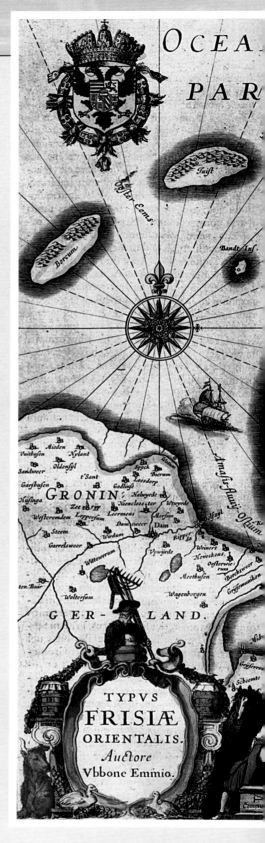

Left:
In 1626 Count Rudolf Christian of East Frisia (1602–1628) introduced a new shield which proclaimed »Arise, free Frisians« and merged the coats of arms of the chief East Frisian tribal dynasties.

Above:
This map of East Frisia was penned in 1645 by Professor Ubbo Emmius from Greetsiel.

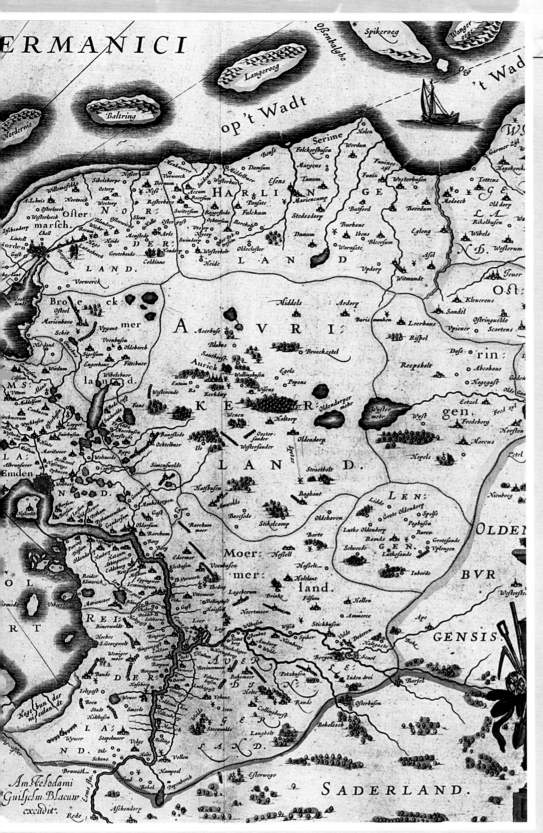

Right, from top to bottom:
Rudolf Christoph Eucken (1846–1926) from Aurich was awarded the Nobel Prize for Literature in 1908.

Theologian, historian, teacher and founder vice chancellor of the university of Groningen Ubbo Emmius (1547–1625) is famous for his »Sixty Books of Frisian History«.

Wolfgang Petersen, born in 1941 in Emden, is a film producer and director. He has earned his laurels internationally as the man who made »Das Boot« (The Boat, 1981) and »Die unendliche Geschichte« (The NeverEnding Story, 1984).

East Frisian extraordinaire: comedian Karl Dall, born in Emden in 1941.

Right:
Schloss Jever was refurbished in the style of the Renaissance during the 16th century and is the most important secular building in town. In 1921 a museum was opened here which informs visitors about the cultural history of the Jeverland.

Far right:
The steeple of the Lutheran parish church in Jever. It was built in 1964 to replace its predecessor which was consumed by fire in 1959.

Below:
The old town in Jever has plenty of good shops and pubs, the latter providing plenty of opportunity to sample some of the famous Jever beer brewed here.

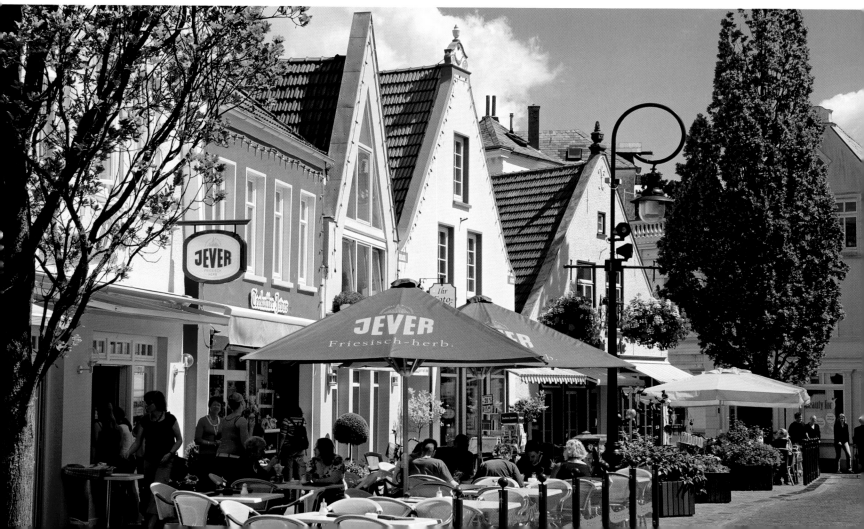

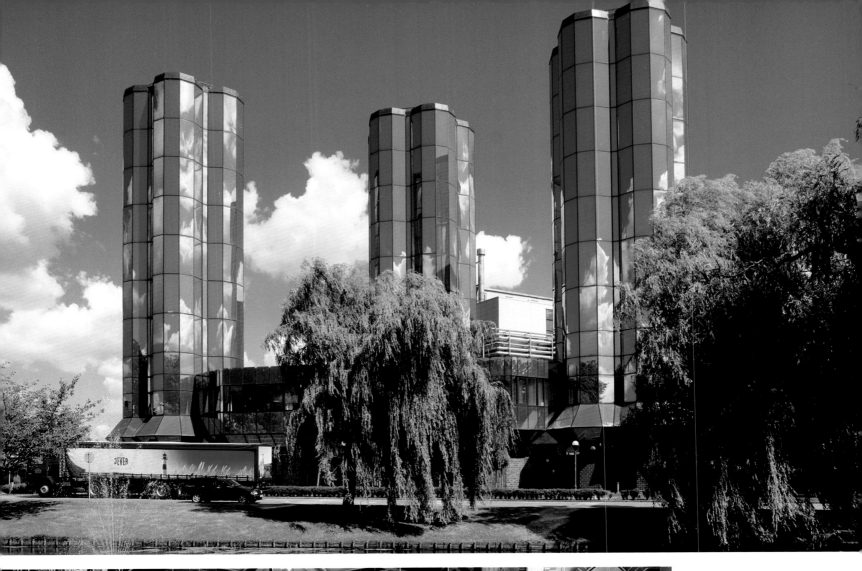

Jever beer has been brewed by the Friesiches Brauhaus since 1948. These massive, reflective towers contain the tanks where the young beer is stored for three to four weeks at a temperature of -1°C.

Left:
Southwest of Jever is the little village of Reepsholt. Its church of St Mauritius was built in c. 1200; the early Gothic choir (shown here) dates back to the end of the 13th century.

Above:
One of the landmarks of Aurich is the Pingelhus, constructed in c. 1800. It takes its name from the Low German word »pingeln« (»to ring«) after the bell sounded here ten minutes before the ferry left for Emden, warning passengers to make ready.

Right:
The administrative offices in Aurich were built between 1898 and 1901 in neo-Renaissance. They house the local government for the region of East Frisia.

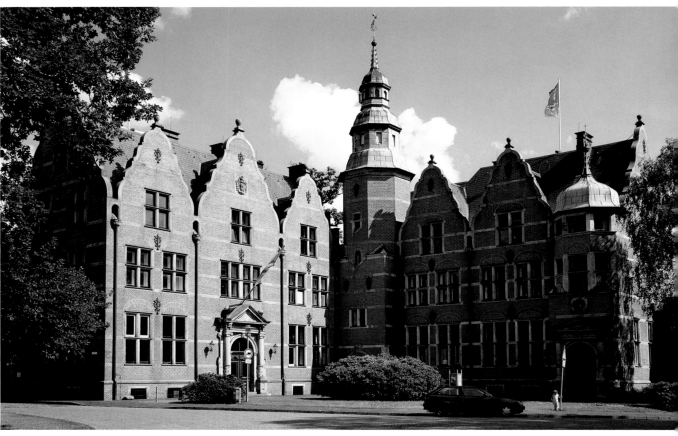

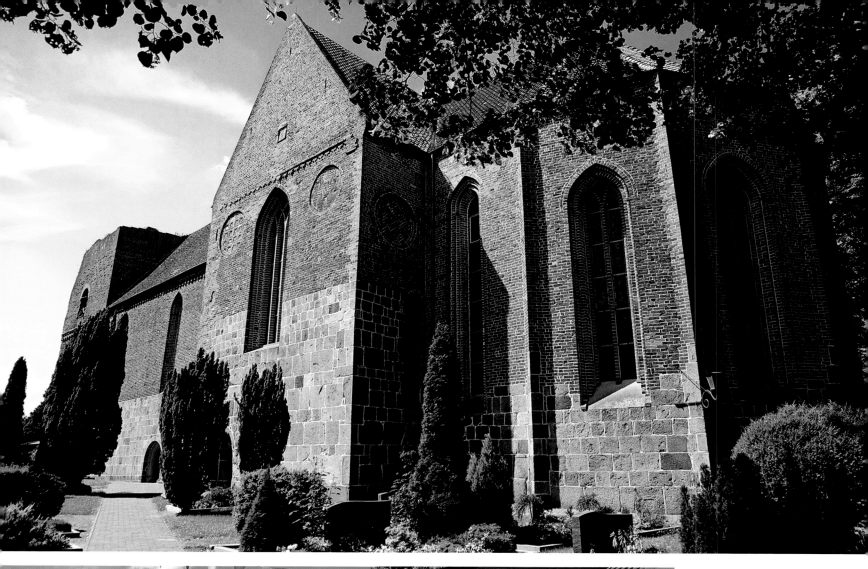

Above:
St Mauritius in Reepsholt.
The church tower was
destroyed during a siege
in 1474; since then the
ruin has been the village
landmark.

Left:
In the pedestrian zone in
Aurich. During the Second
World War the town was
spared the bombs, meaning
that much of its historic
fabric has survived.

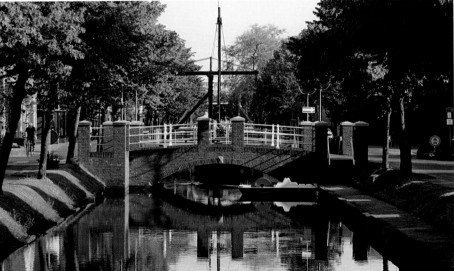

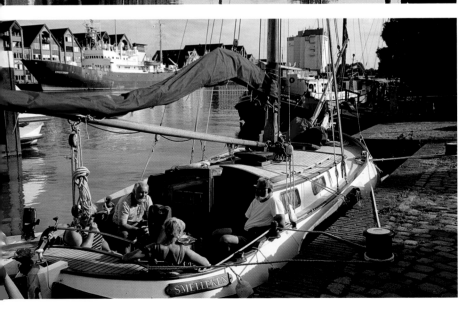

Top left:
The Friederike, a replica
wooden brig, is part of the
open-air maritime museum
in Papenburg and can be
found on the main canal

right outside the town hall.
You can go aboard and ask
for information; the ship
is used by the local tourist
office.

Centre left:
The shipyard town of
Papenburg is riddled with
canals originally built to

Bottom left:
Holidaymakers in the harbour at Leer. The ship in the background, the MS Emsstrom, is used as a training centre for mariners.

Below:
Leer, the third largest town in East Frisia after Emden and Aurich, has a historic centre which shouldn't be missed! In the middle of the photo is the Alte Waage or old weigh station, with the 'fake' Dutch Renaissance town hall from 1894 next to it.

nsport peat. Replicas of ditional marine craft w gently glide along wider of them.

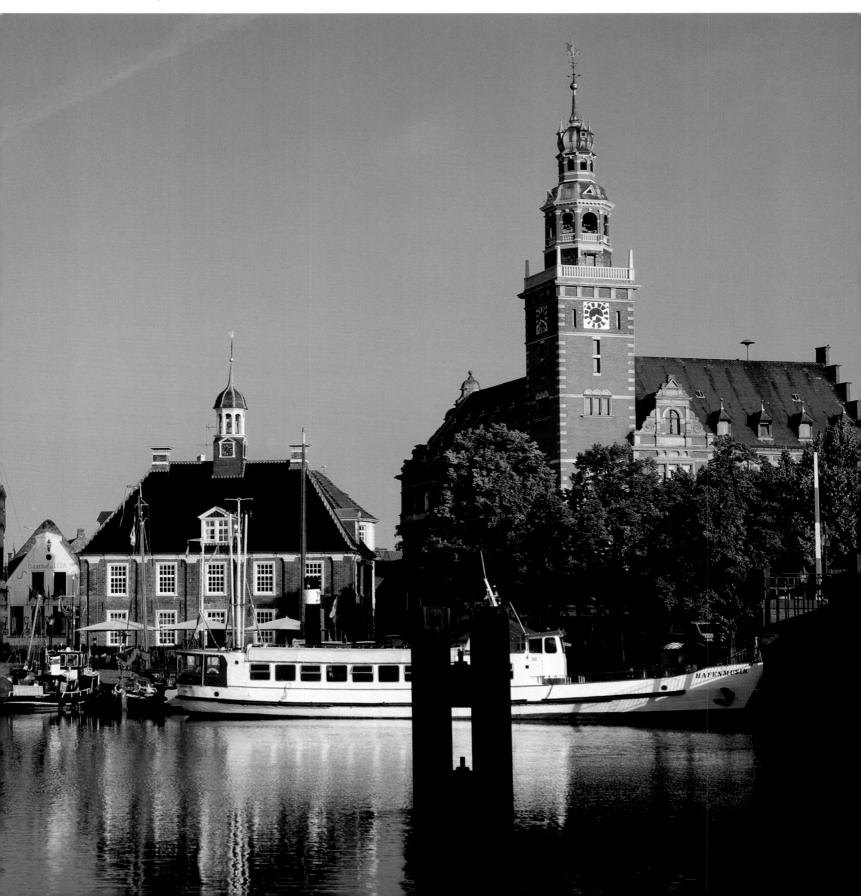

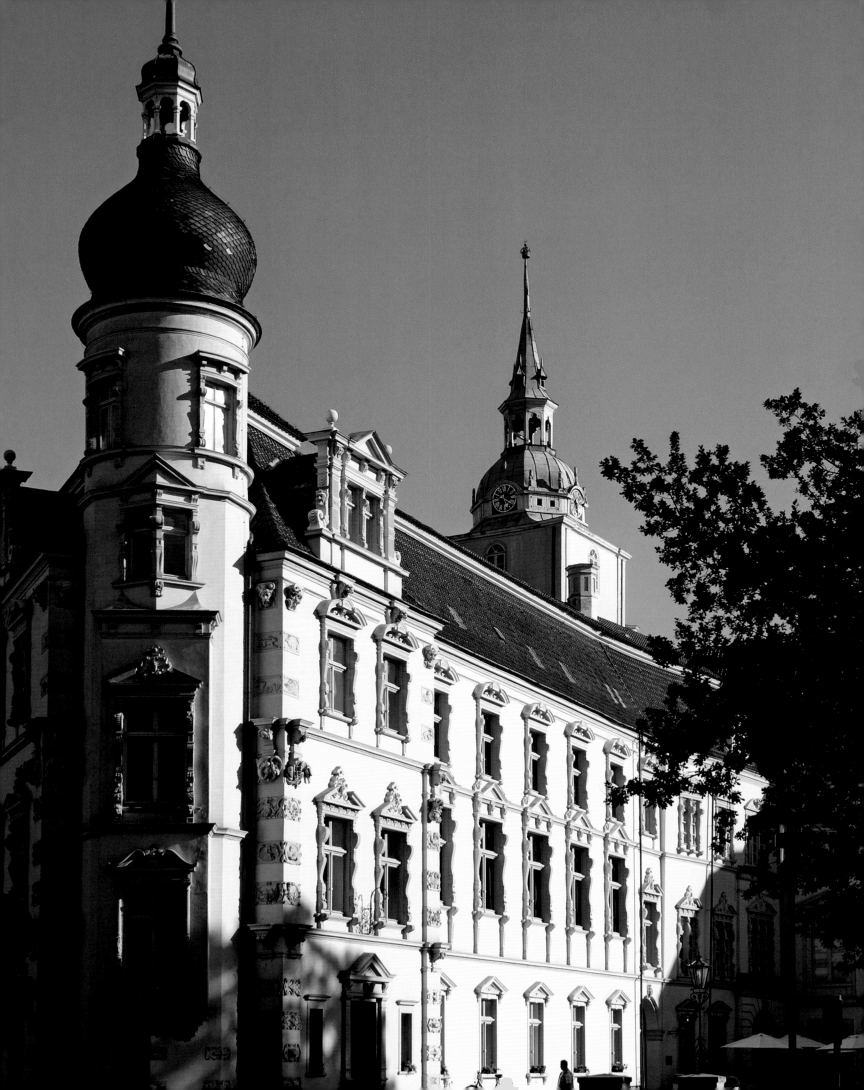

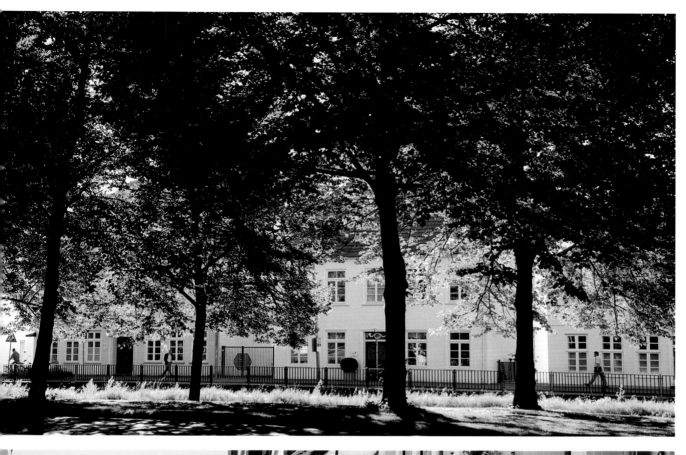

Left page:
Schloss Oldenburg is the former residence of the counts, dukes and grand dukes of Oldenburg. The palace is now a museum of art and cultural history.

On Paradewall in the old royal capital of Oldenburg, once part of the town fortifications. After they were torn down in 1791 the area was turned into a park.

Bergstraße is one of the prettiest little streets in the pedestrianised Nikolai-viertel in the historic part of Oldenburg. You can spend many a happy hour browsing in the boutiques and relaxing in the pubs and cafés here.

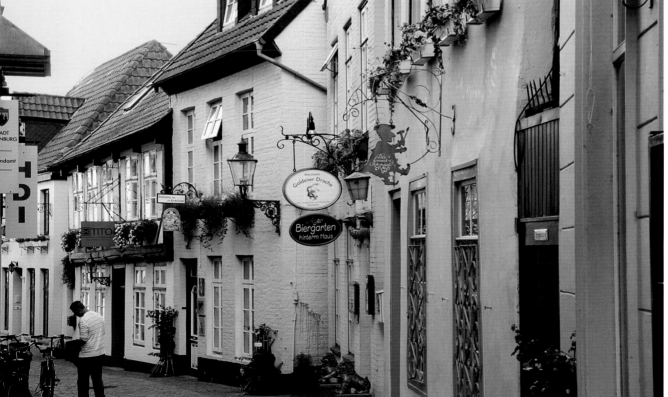

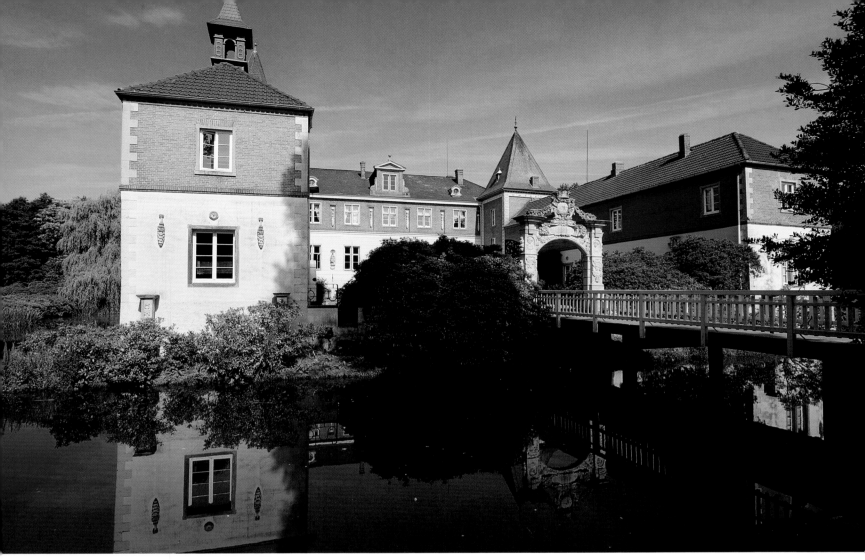

Above:
The moated castle of Dankern near Haren on the Ems is over five hundred years old. It took on its present guise between 1890 and 1894.

Right:
Gut Altenkamp southwest of Papenburg stages exhibitions put on by the Stiftung Preußischer Kulturbesitz or foundation of Prussian culture. The baroque gardens also make a marvellous setting for concerts and other public events.

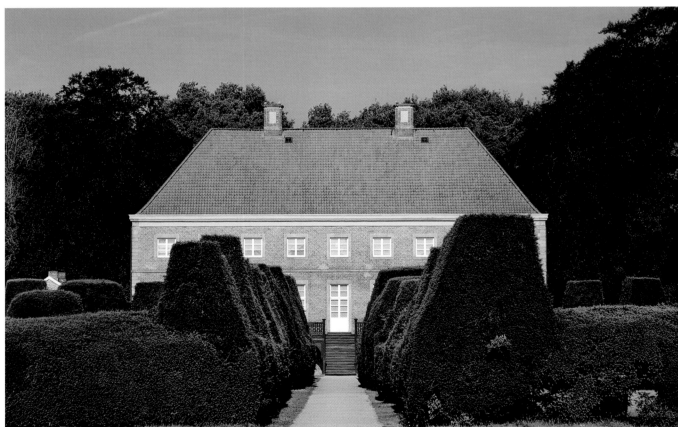

Left:
Cornfield near an Artland farm shaded by ancient trees. Over the centuries the fertile Artland grew rich from its yields of grain, with magnificent farmhouses a grand manifestation of the wealth of their former owners.

Below:
Tree-lined avenues are another feature of the Artland between Quakenbrück, Badbergen, Nortrup and Menslage.

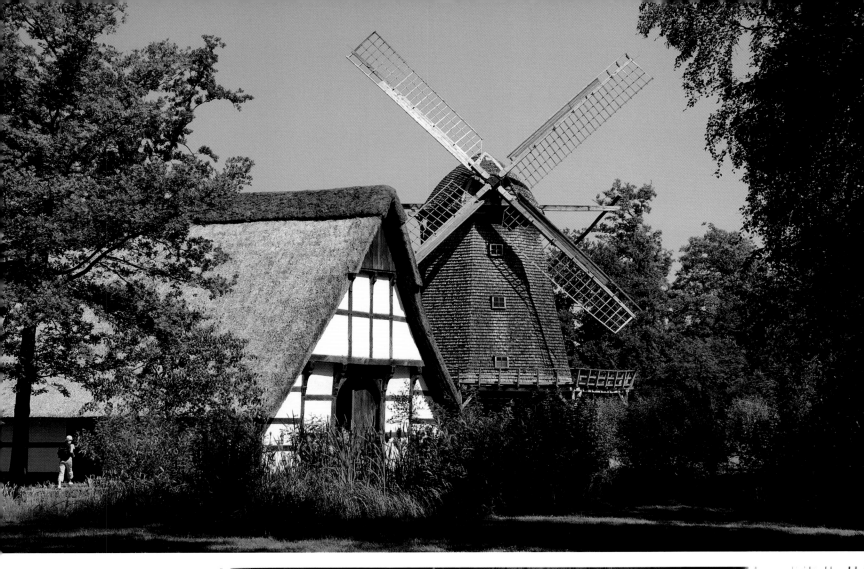

Lower Saxony's official open-air museum and the oldest in Germany is the museum village of Cloppenburg, founded in 1934. Over 50 historic buildings from the 16th to the 19th century have been re-erected here, including a windmill (top) and a smoke-house (right), where people and animals lived under one roof, huddling for warmth around the meagre open fireplace.

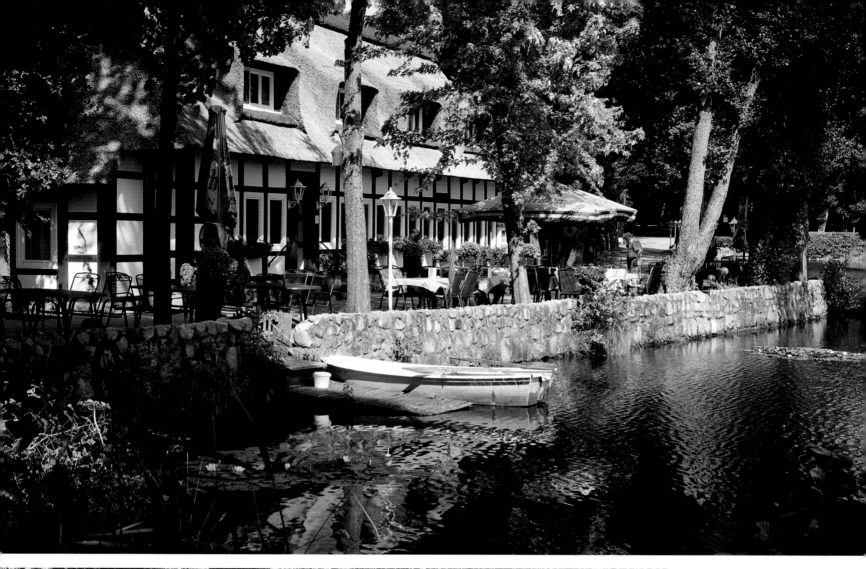

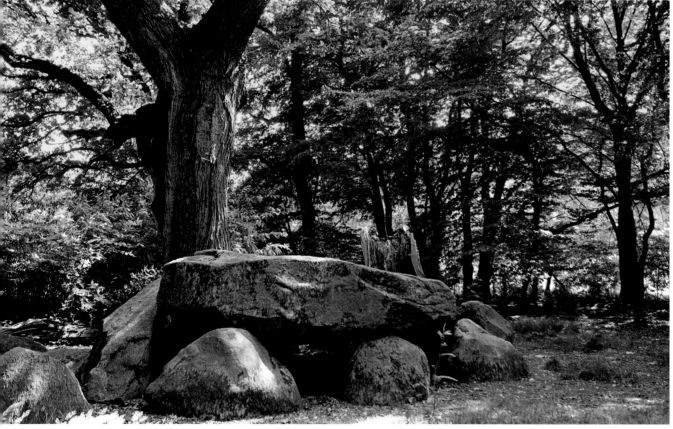

Above:
The pretty restaurant of Neumühle is northeast of Visbek in the Oldenburger Münsterland. There are grand views of the lake of Mühlensee from the terrace.

Left:
This megalith northwest of Visbek was thought to be a heathen place of sacrifice in the 19th century, with people believing that the groove in the surface was to allow blood to run off the sacrificial table. We now know that it is 'just' a Stone Age tomb.

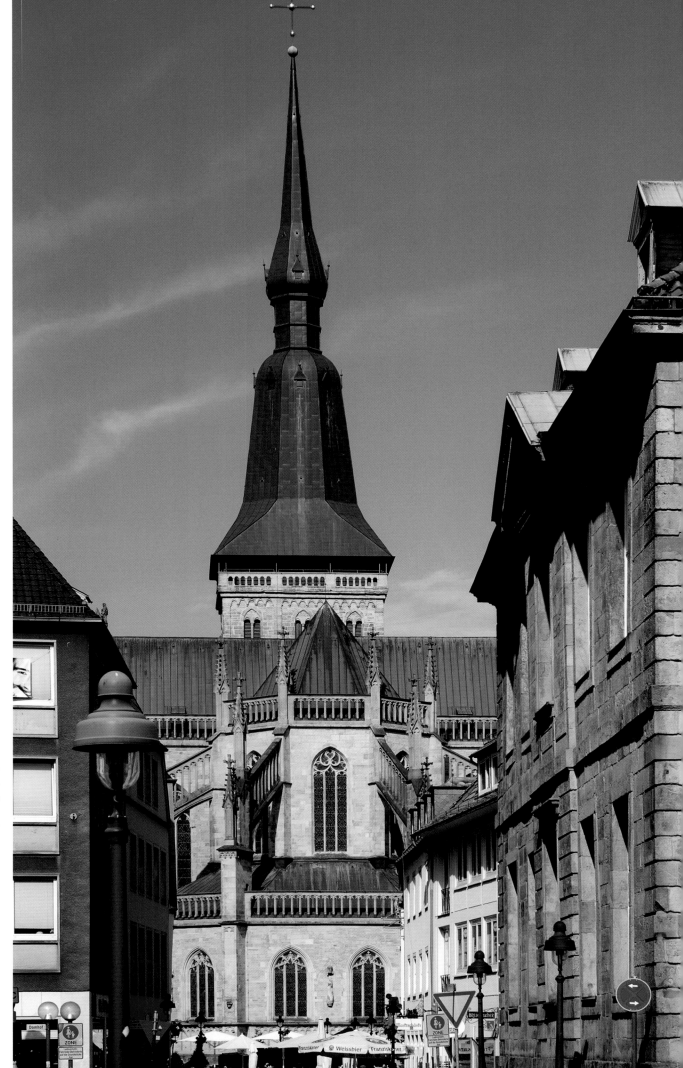

The centre of Osnabrück has a lot to see. The Gothic Marienkirche is a product of the 10th to 15th centuries and forms an architectural whole with the Rathaus and city weigh house.

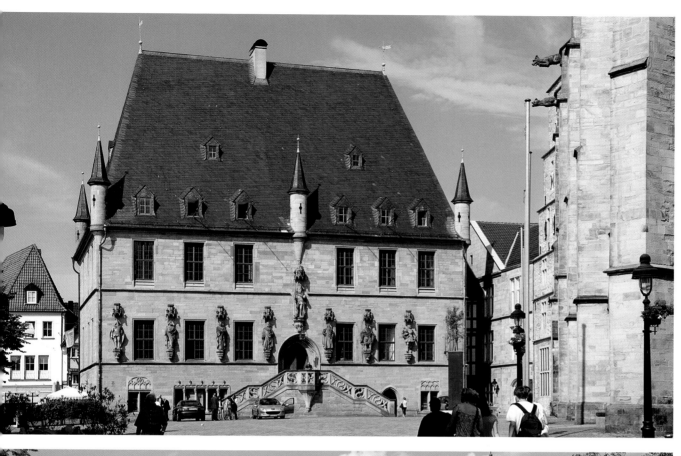

The landmark of 'town of peace' Osnabrück is undoubtedly its late Gothic Rathaus or town hall, put up between 1487 and 1512. Osnabrück was one of the places where in 1648 the warring factions of the Thirty Years' War negotiated and signed the Peace of Westphalia.

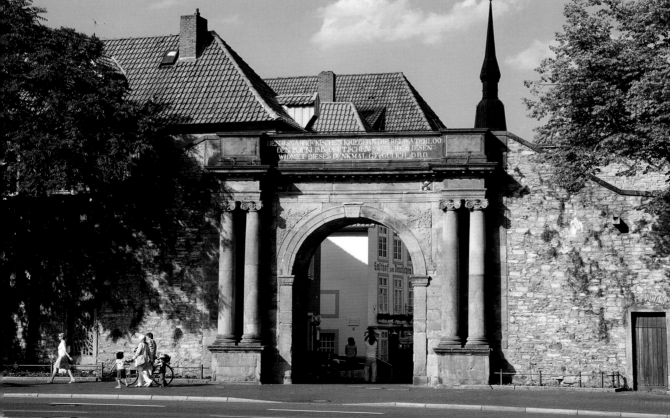

The Heger Tor in Osnabrück was built in 1817 and is a memorial to the Osnabrück soldiers of the King's German Legion who in 1815 fought in the Battle of Waterloo. There is a viewing platform on top of the gate.

65

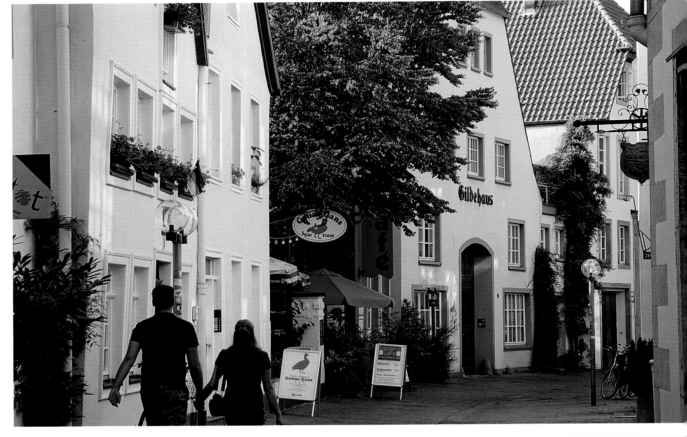

In the old town of Osnabrück not far from the Heger Tor – and never more than a few paces away from a café or pub! The writer Erich Maria Remarque (1898–1970), he of »All Quiet on the Western Front«, was born in Osnabrück.

This garden café, not far from the Heger Tor, is actually on top of the old city fortifications.

Right page:
Marienstraße in Old Osnabrück. Most of the original buildings were bombed in 1944. In an attempt to recreate the historic flair of the town, half-timbered houses from the neighbouring area were dismantled and rebuilt on site, one of them being Haus Bramsche from 1692 which is now a restaurant.

Between Elbe and Weser – from Cuxhaven to the Lüneburger Heide

Heather in bloom in the Naturpark Südheide. About 525 hectares (1,300 acres) of the heath here are covered in deep pink and purple Calluna vulgaris.

At the mouth of the River Elbe lies the harbour town of Cuxhaven, popular with hobby mariners for its many museums and nautical sights. With over ten million trees the Altes Land, part of the Elbmarsch, is Germany's biggest fruit plantation. In the spring the area is a sea of pink and white blossom. The flat scenery makes perfect cycling country, with barely a hill in sight to impede your gentle pedalling.

For an even more leisurely journey you can board the Moorexpress between Stade and Bremen, a nostalgic rail bus which tours the unusual landscape of the Teufelsmoor. Special trips enable you to sample the culture and culinary delights of the region. One of the stops along the way is the artists' colony of Worpswede, a big attraction for art aficionados and those seeking rest and respite.

The Mittelweser holiday region stretches from Minden and Hannover in the south to Bremen in the north, a tranquil river valley with a long architectural and artistic history. No other region in Europe can claim to have as many Renaissance buildings as here, giving rise to the phrase »Weser Renaissance«. Between the Weser and Hannover is the Steinhulder Meer, the biggest inland lake in northwest Germany, and not far from here stands the old Cistercian monastery of Loccum which dates back to the late Romanesque.

Lüneburg is one of the few cities in the north of Germany that was able to get its historic centre through the Second World War unscathed. It's thus also called the Rothenberg of the North, after Rothenburg ob der Tauber which was also miraculously spared the bombing. The unique landscape of the Lüneburger Heide is beautiful all year round – and not just in August and September when the heather blooms a glorious reddish purple. Celle on the edge of the Lüneburger Heide has a wonderful old centre with almost five hundred restored half-timbered buildings.

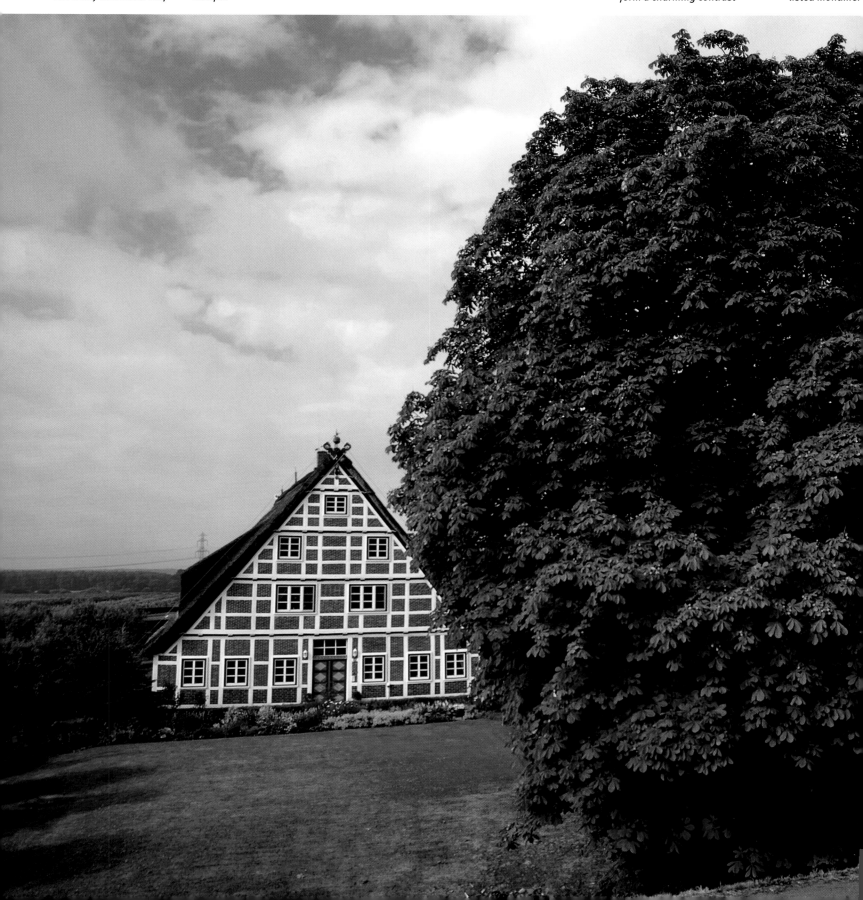

Below:
Farm in the Altes Land, part of the Elbmarsch southwest of Hamburg. The richly decorated half- *timbered buildings are typical of the largest fruit growing area in Central Europe.*

Top right:
Many of the gaps in the half timbering are filled with plain bricks which form a charming contrast *to the white beams. houses are often thatc with reeds and many listed monumen*

Centre right:
The grand arch of an Altes Land farmhouse. Carved and painted gates such as these, many inscribed with local sayings, are peculiar

to the Altes Land. Estates had to farm at least 25 hectares (60 acres) to be allowed to erect such a prestigious edifice.

Bottom right:
This huge house simply oozes money – that of its former inhabitants! The bricks between the beams are particularly artfully arranged in a testament to wealth.

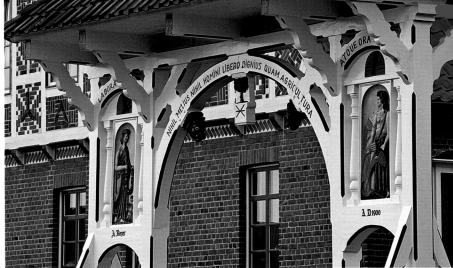

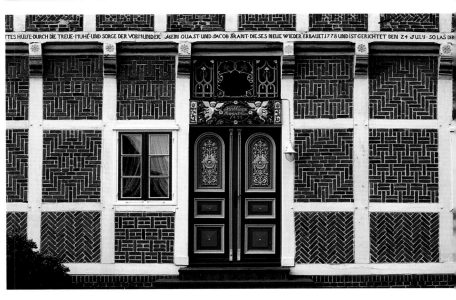

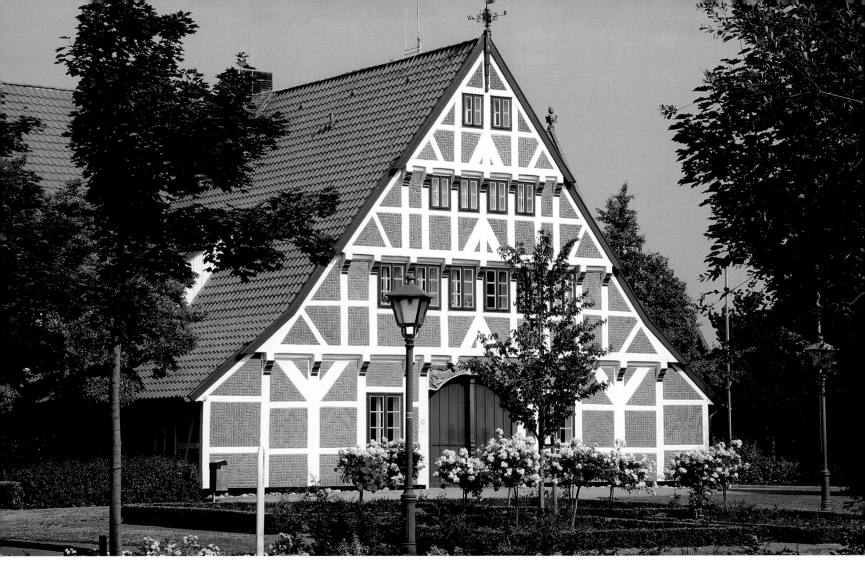

Above:
At the heart of the Altes Land is Jork. With its proud half-timbered farmhouses, the village is pretty all year round – and even more so when the fruit trees are in blossom.

Right:
In the centre of Jork. In the past several famous names have chosen this picturesque place to get married in – one being poet of the Enlightenment Gotthold Ephraim Lessing in 1776, and another East Frisian comedian Otto Waalkes.

72

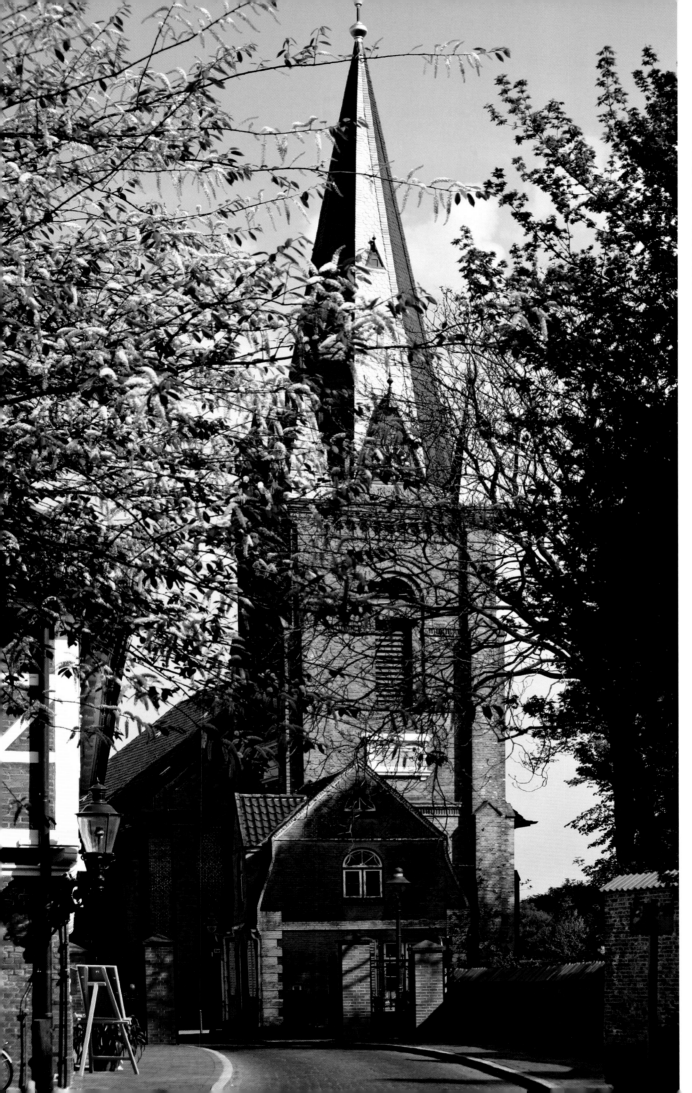

The Martinskirche in
Cuxhaven-Ritzebüttel was
erected between 1816 and
1819 as a simple, neo-
classical house of prayer.
The distinctive steeple was
added in 1883. Cuxhaven
at the mouth of the Elbe
on the North Sea belonged
to Hamburg from the
13th century to 1937.

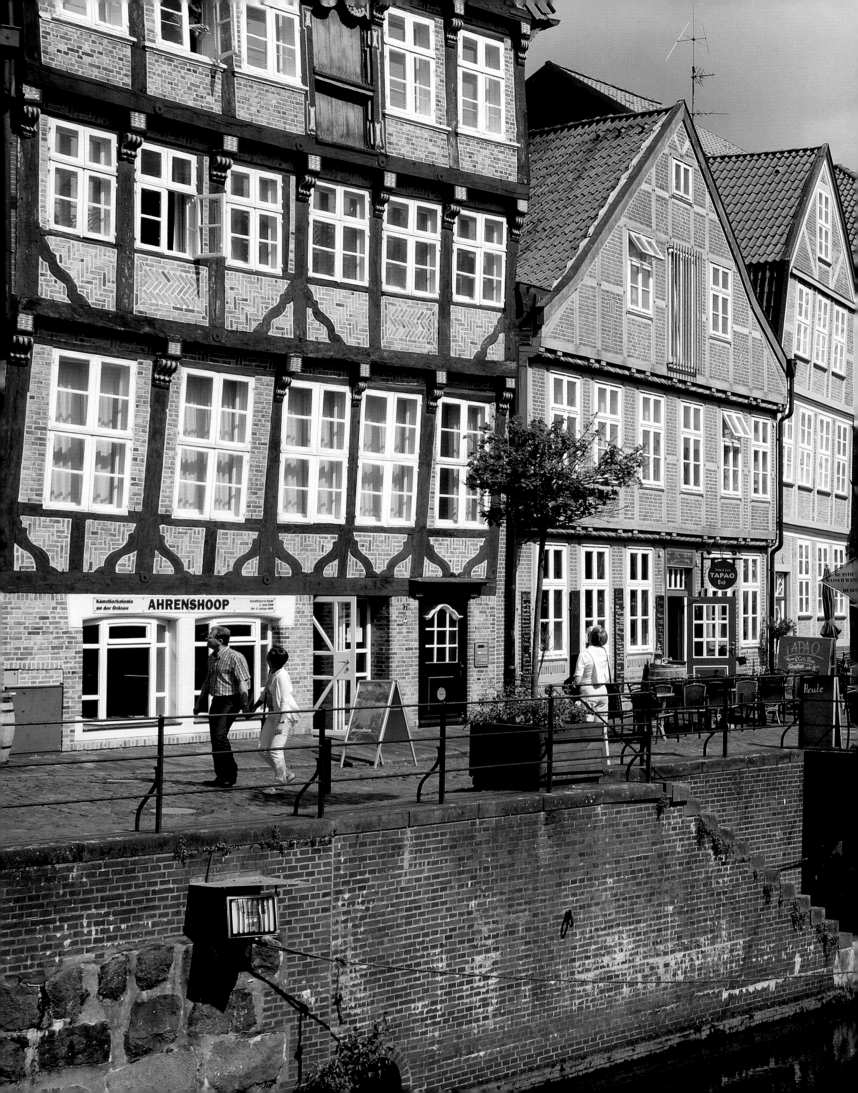

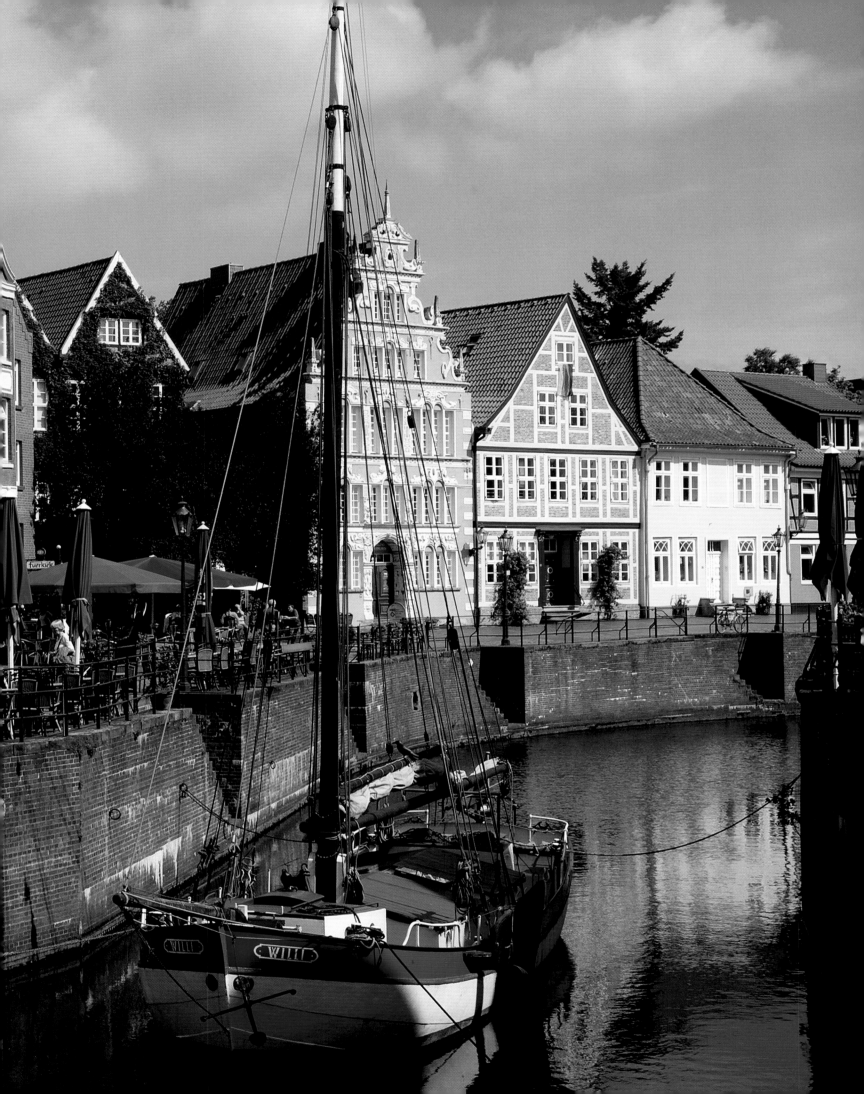

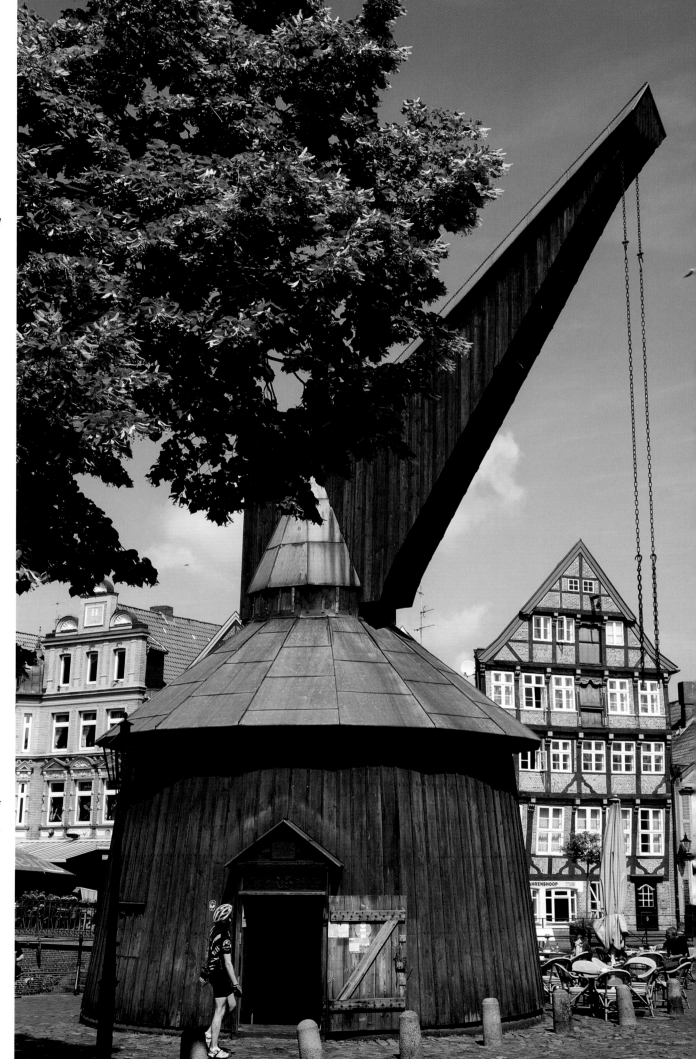

Page 74/75:
The Hansas' harbour in the old Hanseatic port of Stade. In the mid 1970s the city council considered filling in the harbour and turning it into a car park – which they luckily didn't do!

In 1977 on the site of the Stade salt crane from 1661 a tread crane based on a similar contraption in Lüneburg was erected. The original was torn down in 1898.

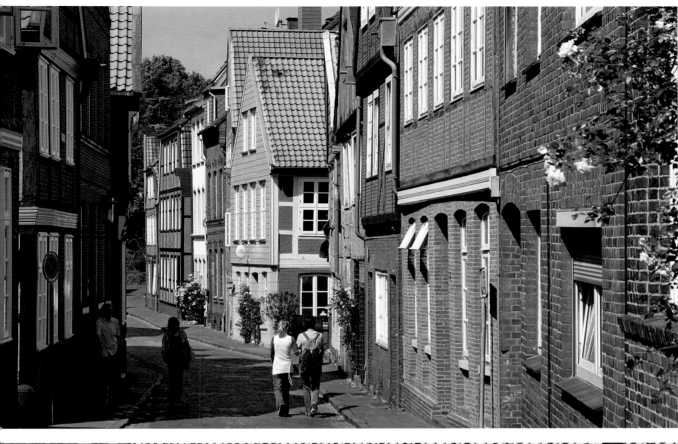

The sights of Stade include the entire old town with its cheerful multitude of half-timbered houses, most of which date back to the time after the city fire of 1659.

The Hahnentor in the old town of Stade goes back to 1658; the arch under the top storey leads onto Kalkmühlenstraße.

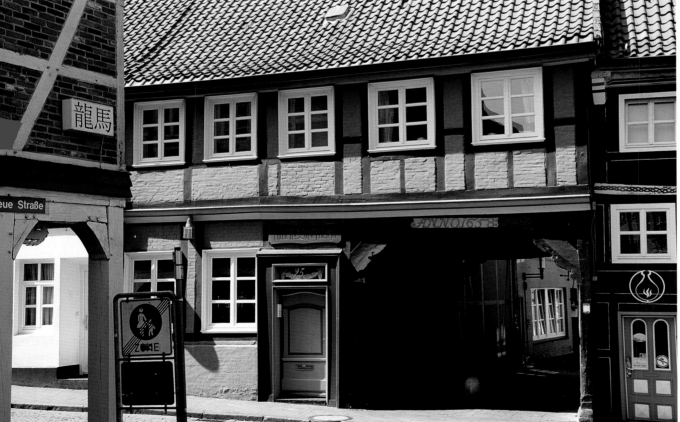

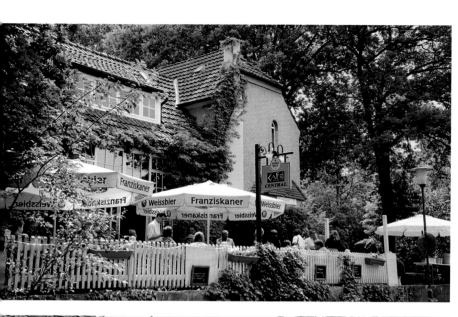

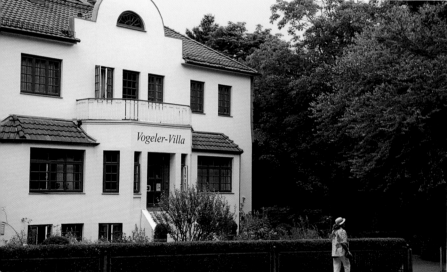

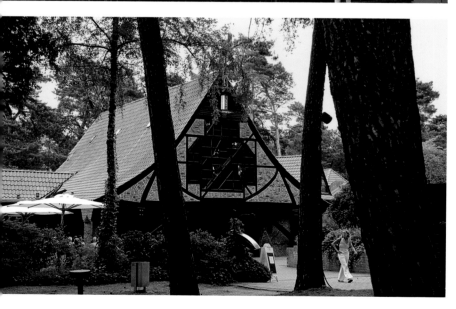

Top left:
Worpswede lies northeast of Bremen in the middle of the Teufelsmoor and is famous for the artists' colony founded here in 1889. Here, Café Central on Bergstraße.

Centre left:
Artist Heinrich Vogeler built himself this splendid villa. The listed building is now a home for the elderly and infirm.

Bottom left:
Kaffee Worpswede, also known locally as Kaffee Verrückt (café mad), is an Expressionist edifice at the foot of the Weyerberg. It has served as a café and restaurant since 1925.

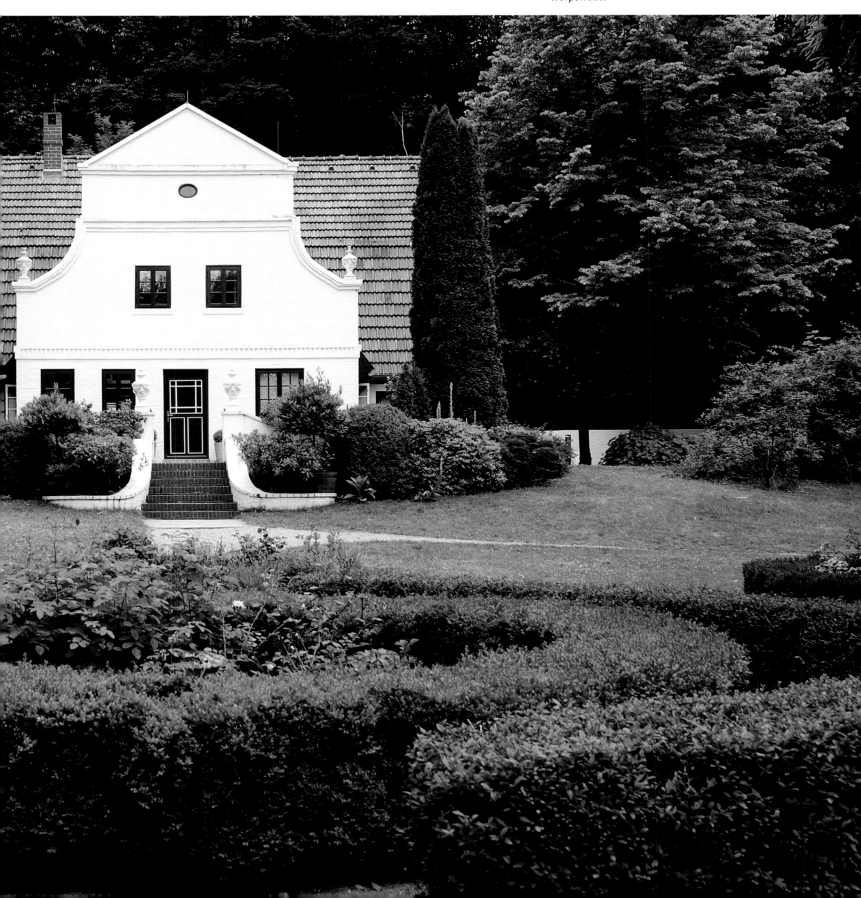

Below:
Barkenhoff, once a farm-house, was acquired by Heinrich Vogeler in 1895 and redone in Jugendstil. It soon became the hub of artistic activity in Worpswede.

Artists' colony on a devil's moor – Worpswede

Northeast of Bremen, in the midst of the Teufelsmoor or Devil's Moor, is Worpswede, huddled at the foot of the rotund Weyerberg, a tree-covered sand dune just 54.4 metres (178.5 feet) high. And this is exactly what Worpswede means: »hill, wooded«. At the end of the 19th century it was just a hamlet; today it's a large village with a population of 10,000.

In 1884 a student from the art academy in Düsseldorf, Fritz Mackensen (1866–1953), started to spend his summers painting here. He later brought a friend with him: Otto Modersohn (1865–1943). Like many of the artists of their day they wanted to get out of town and into the fresh air and the light, where there were rural motifs and country idyll in abundance.

Otto Modersohn was soon prompted to voice a demand: »Away with the academies [...] Nature is our teacher, and we must act accordingly«. In 1889 the young artists did just that, not returning to Düsseldorf but instead staying in Worpswede. They were joined by painter and etcher Hans am Ende (1864–1918) who had studied in Munich and Karlsruhe. The three of them founded an artists' colony.

Others quickly followed: Fritz Overbeck, Carl Vinnen, Bernhard Hoetger and Heinrich Vogeler, for example. Vogeler bought up an old farmhouse in Worpswede in 1895, the Barkenhoff or Birkenhof (birch farm), and had it refurbished in Jugendstil. The Barkenhoff became the epicentre of the colony.

Paula Modersohn-Becker

The most outstanding person in the artistic circle proved to be Paula Modersohn-Becker (1876–1907). Born in Dresden in 1876, Paula Becker first saw pictures by Worpswede artists in 1893. As a woman she was barred from entering an art academy. In 1896 she visited a renowned school of art in Berlin where eleven years previously Käthe Kollwitz had begun her training. In 1897 she came to Worpswede on a family outing. The village and its colony of artists greatly impressed her. »Worpswede, Worpswede, Worpswede ... It is a wonderland«, the young lady effusively wrote in her diary. She came back in the autumn of 1898 to take lessons with Fritz Mackensen. In the following years she went to Paris on several occasions, seeing the works of Cézanne, van Gogh and Gauguin and drawing inspiration from them.

In 1901 Paula married the widowed Otto Modersohn. In the same year her friend, the sculptress Clara Westhoff, married poet Rainer Maria Rilke who had come to stay with Heinrich Vogeler in Worpswede in 1900. In the »sentimental, musty, ethereal earthiness and introversion of the Worpswede artists' colony« (to quote art historian Eberhard Roters) Paula Modersohn-Becker developed her very own Expressionist style. One patron of the Worpswede artists, Bremen coffee magnate Ludwig Roselius, called her a »painter of truth«. For him, Paula was a clear cut above the otherwise conventional school of painters: »... without comparison she rose like a genius above the talented«.

In 1907 her greatest wish was fulfilled and she finally became pregnant. On November 2 her daughter Mathilde was born (d. 1998). The doctor ordered her to rest. She died on November 30 of an embolism, just 31 years old. Otto Modersohn recorded her last words: »What a shame«.

Paula Modersohn-Becker has left us around 750 paintings and 1,000 drawings. Excerpts from her great oeuvre can be viewed at the Große Kunstschau Worpswede exhibition, alongside works by other masters of the first Worpswede generation. It's also worth going to exhibitions by contemporary artists for whom Worpswede is still a top venue. Art and nature, culture and countryside here form a unique artistic whole. Rainer Maria Rilke once tried to encapsulate the magic of Worpswede in words: »And there, before those young people who had come to find themselves, lay the many puzzles of this land. The birch trees, the moorland huts, the heathland, the people, the evenings and the days, of which no two are the same and in which there are no two hours one could confuse. And they went on to love this puzzle.«

Left:
The Modersohn-Haus belonged to Otto Modersohn from 1898 to 1921.

Above:
Worpswede artist Traute Bode exhibiting her works of art which largely featur[e] flowers and landscapes.

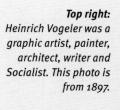

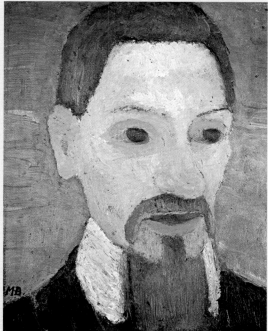
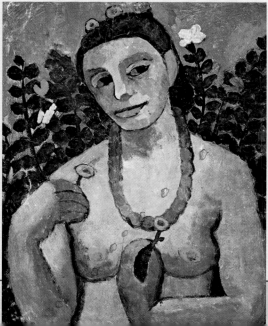

Top right:
Heinrich Vogeler was a graphic artist, painter, architect, writer and Socialist. This photo is from 1897.

Centre right:
Rainer Maria Rilke, as painted by Paula Modersohn-Becker in 1906.

Right:
Perhaps the most enigmatic artist in Worpswede was Paula Modersohn-Becker, depicted here in a self portrait from 1906.

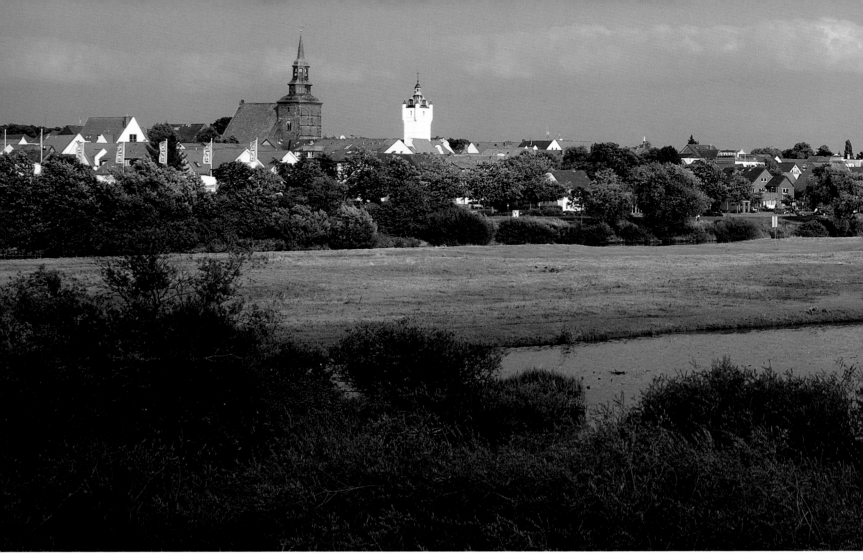

Right:
The Rathaus in Verden. Areas worth seeing include the old town, the horse museum on Holzmarkt and the only monument dedicated to John Lennon in Germany, erected to commemorate the filming of »How I Won the War«. Some of the scenes were shot in the old part of Verden.

Far right:
Am Lugenstein in Verden. The former dormitory near the cathedral, its Renaissance gable added in the 16th century, was later a school.

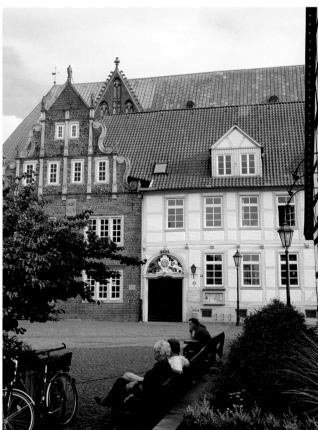

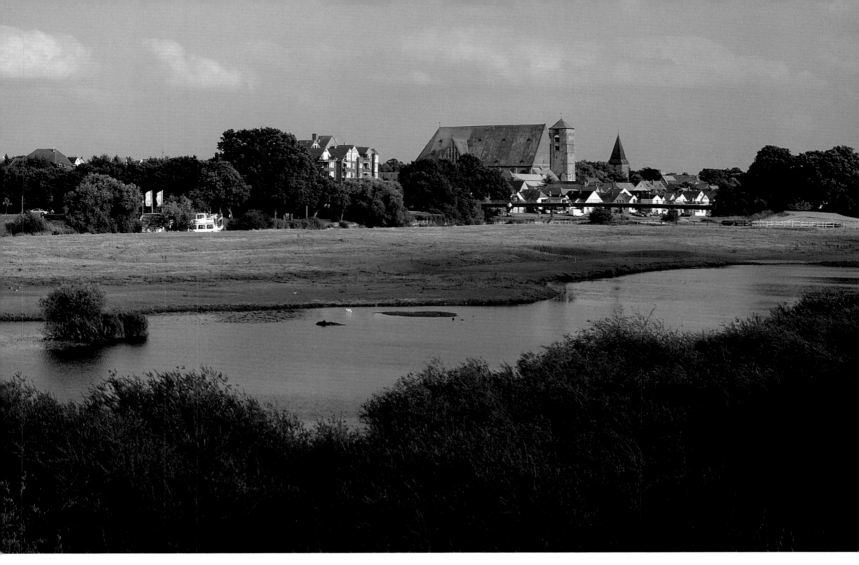

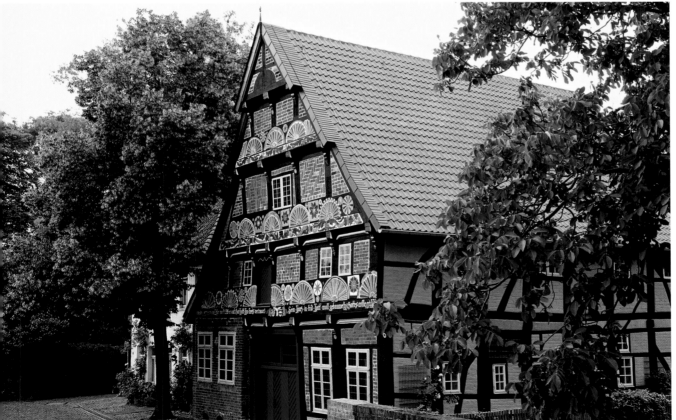

Above:
View across the river of Verden. The town lies on the River Aller shortly before its confluence with the Weser. Verden is famous for its stud breeding and equestrian sports, earning it the epithet of 'rider's town'.

Left:
One of the most beautiful half-timbered Renaissance houses in Lower Saxony is on Strukturstraße in Verden. Built in 1577, it is richly ornamented with fanned roses and was extensively restored in the summer of 2004.

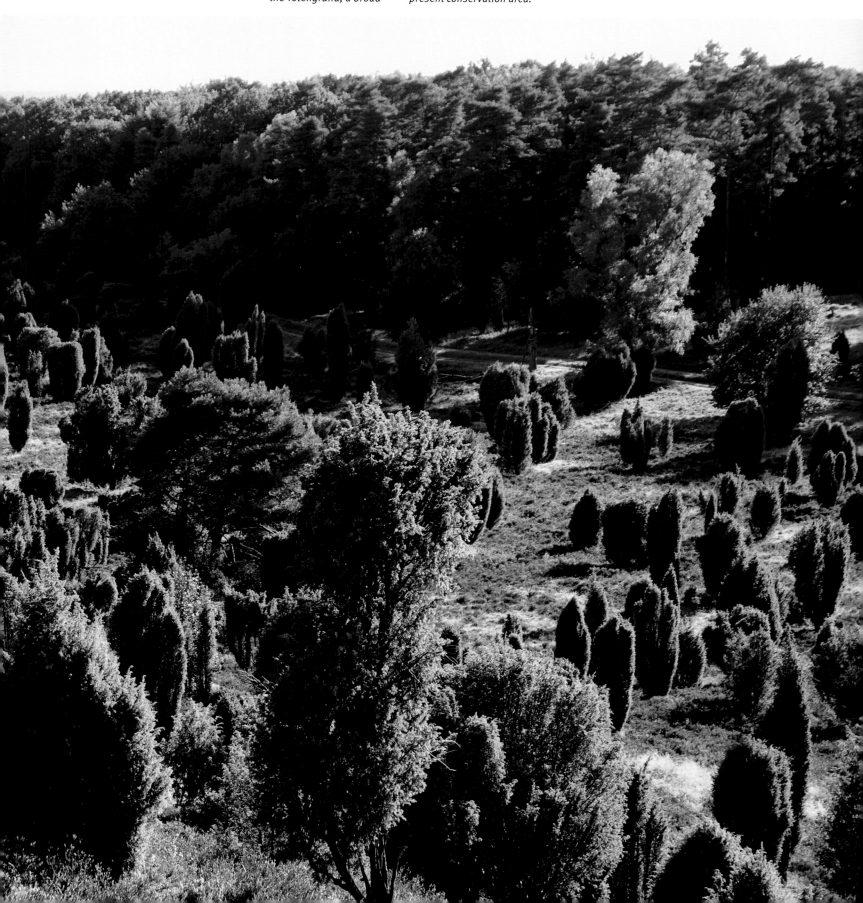

Below:
Naturpark am Totengrund
near Wilsede. In 1907
the Totengrund, a broad

heathland valley sown
with juniper, became the
chief component of the
present conservation area.

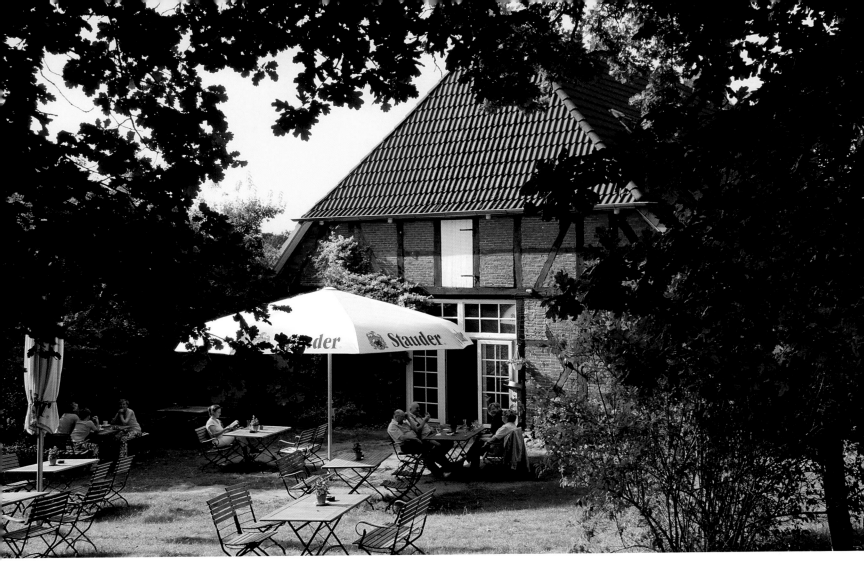

Above:
There are plenty of places to stop off for some refreshment in the Lüneburger Heide. Here, Kaap's Restaurant in Sahrendorf, three kilometres (two miles) east of Undeloh.

Right:
The majority of the Lüneburger Heide National Park (about 58 percent) consists of pine forest planted in the second half of the 19th century.

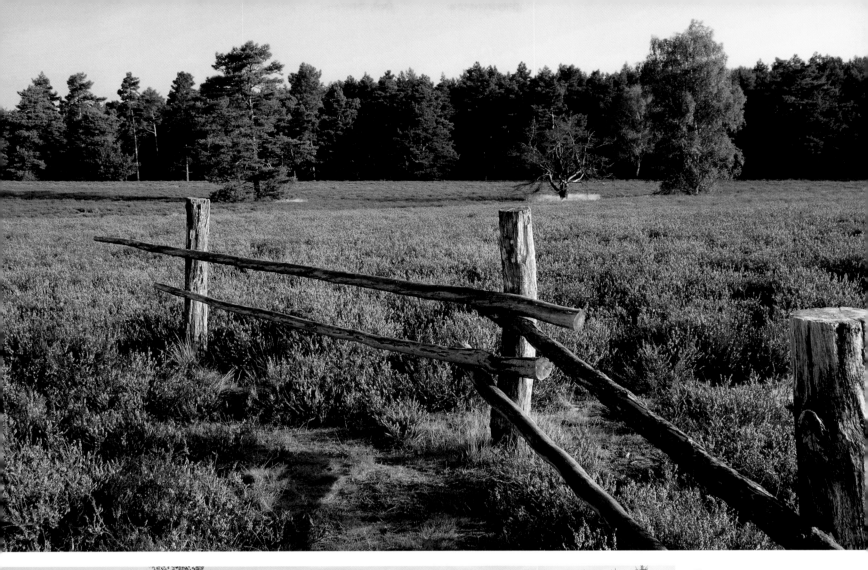

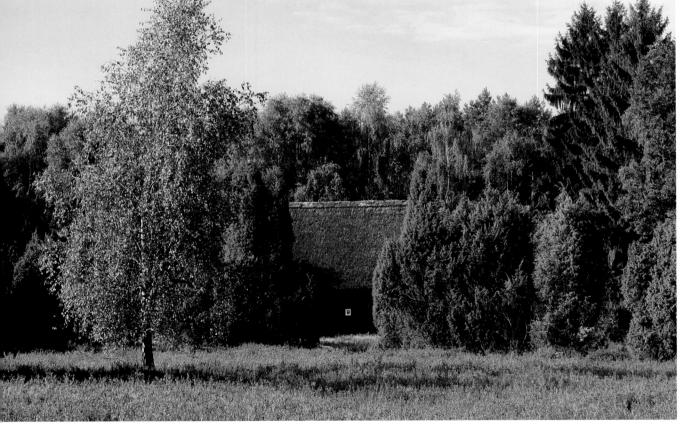

Above:
Heather in bloom in the Naturpark Südheide, made a German national park worthy of conservation in 1964.

Left:
The biggest forest fire in the history of West Germany was the devastating fire on the Lüneburger Heide in 1975. It also affected the Naturpark Südheide where about 6,000 hectares (15,000 acres) of woodland, moor and heath were burnt to a cinder.

THE LÜNEBURGER HEIDE
AND ITS SHEEP

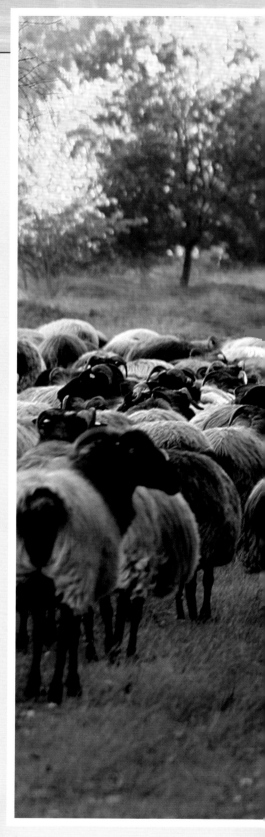

Away from the city! And there it sprawls, / The heath: misty, ghostly, / The wind whistling across it, / Oh, here one step is as a thousand!« Thus wrote Friedrich Hebbel (1813–1863) in his poem entitled *Heideknaben* (Heathland Boy). Even though the heath is no longer so eerie, it is fascinating in that it's so different. The Lüneburger Heide – or Lüneburg Heath, to give it its English name – is a swathe of moorland on the plains of the Norddeutsche Tiefebene in the northeast of Lower Saxony. It stretches between the Unterelbe and Aller rivers and at over 7,000 square kilometres (2,700 square miles) is the largest area of heathland in Central Europe.

Countryside like this covered much of North Germany up until c. 1800. At the end of the last ice age about ten thousand years ago the first forests began to grow on what is now the heath. Around five thousand years ago people settled here and began farming the land and raising livestock. They cut down the forest and grazed animals or planted crops in the cleared areas.

The trees which tried to grow back were cropped short by grazing sheep; eventually, only plants which could cope with permanent pruning persisted, such as heather, gorse, juniper, bilberry and grass. The Lüneburger Heide has thus not evolved naturally; it is a cultural landscape shaped by human hand. Man again changed its makeup when in the 19th century he began planting up large areas with pine and spruce.

Visitors to the heath find themselves on extraordinary terrain, with a tapestry of forest (about 60%), heath (about 20%), bog and tiny rivers to explore. The highest elevation in the Lüneburger Heide is the Wilseder Berg, 169 metres (555 feet) above sea level. The River Wümme rises on its western slopes. Four large national parks and several conservation areas are intended to help protect this unique habitat which is home to several rare birds, such as the black grouse, European nightjar and woodlark.

Nature's little helpers

In the conservation of this remarkable environment nature has some little helpers. The heath's *Heidschnucken* belong to a group of at least seven different types of sheep which includes the Soay sheep of Scotland and also variations in Sweden, Brittany and what was once East Prussia. They are undemanding and easy to keep, largely feeding off the simple heathland vegetation, their diet supplemented by grain, rape, turnips or potatoes. Their head, legs and tails are black and their wool grey. The lambs are born black and only gain their typical colouring in their second year. Both sexes have horns; a ram can weigh up to 90 kilos (198 pounds) and a ewe about 55 kilos (120 pounds).

In the mid 19th century up to 380,000 *Heidschnucken* were tended in what was then the principality of Lüneburg. They were kept for their dung, meat and wool. The long, straggly wool is too rough for clothing but good for carpets. The amount of meat the sheep yield is fairly low and tastes like game. Over 10,000 *Heidschnucken* currently graze the heath. They are the main protagonists of the Heidschnuckentag in Müden on the River Örtze in the district of Celle, held on the second Thursday in July. The open-air museum in Walsrode focuses on the lives and working conditions of the heath's former inhabitants and is open all year round. Walsrode was also the chosen residence of heathland poet Hermann Löns (1866–1914). One of his poems, *Auf der Lüneburger Heide* (On the Lüneburg Heath), was made popular throughout the land by countless village choirs and sentimental regional films. In Walsrode and the environs he has had many memorials erected in his honour.

Lüneburg Heath National Park draws over four million visitors per annum. The highlight of the year is between the beginning of August and the middle of September when the rough, rather unkempt heather, once used in brooms, smothers the countryside in a brilliant burgundy haze. The heath is then humming with hikers and cyclists, horse-drawn traps and carriages, the air bittersweet with the fragrance of blossom basking in the sun.

Left:
Symphony in green: a juniper heath in the Naturpark Südheide. The evergreen shrubs like dry soil.

Above:
A herd of Heidschnucken sheep in autumn. Easy to look after, the relations of the Soay sheep of Scotland are now bred throughout Europe. They probably originate from the mouflon which live on Sardinia and Corsica.

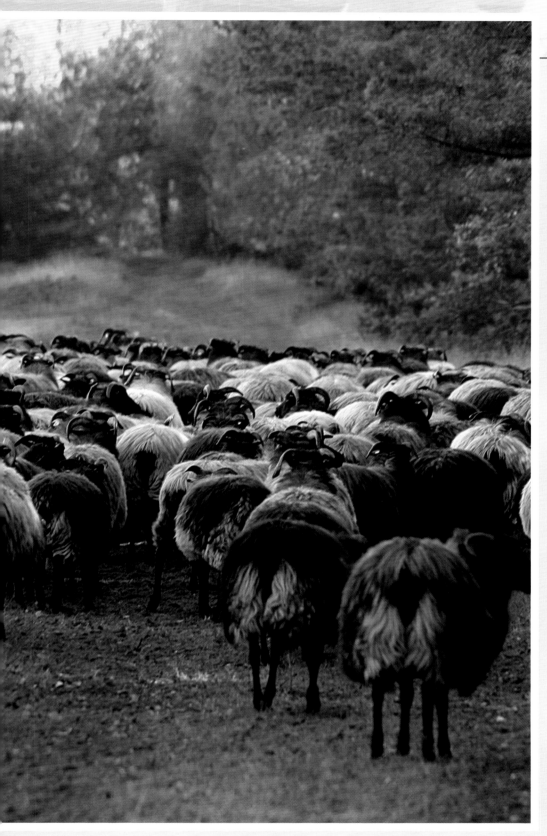

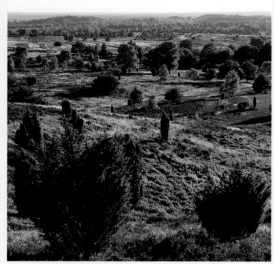

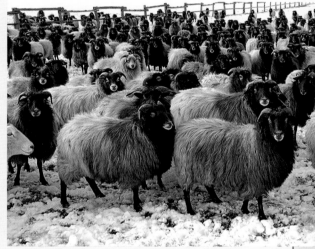

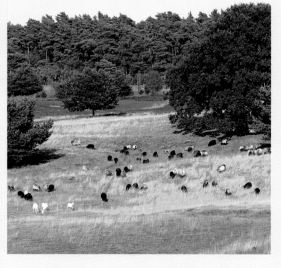

Top right:
View from Wilseder Berg of the flowering heather on the juniper heath. Juniper is a member of the cypress family.

Centre right:
In winter the sheep are kept warm by their long, straggly wool. The wool is too coarse to make clothing from, however.

Right:
A herd of Heidschnucken in summer in an area of pine. Mutton from the Heidschnucken is sold under a registered European trademark; look out for labels bearing the words »Von der Lüneburger Heidschnucke«.

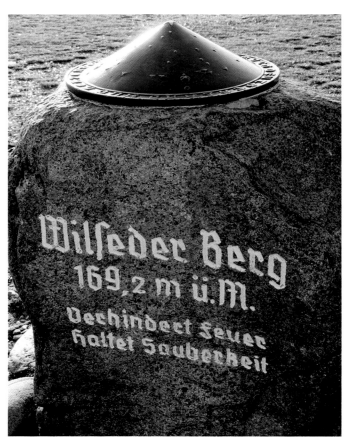

Right:
The Gauß monument on Wilseder Berg. The figure carved in stone here is the work of scientist and land surveyor Carl Friedrich Gauß (1777–1855) who was commissioned by King George IV to measure the kingdom of Hannover. Wilseder Berg is the highest point in the Norddeutsches Tiefland, the plains of North Germany.

Far right:
This monument on Wietzer Berg near Müden (Örtze) is dedicated to heathland poet Hermann Löns.

Below:
A great way to explore the enchanted landscape of the Lüneburger Heide is on horseback: here on Wietzer Berg.

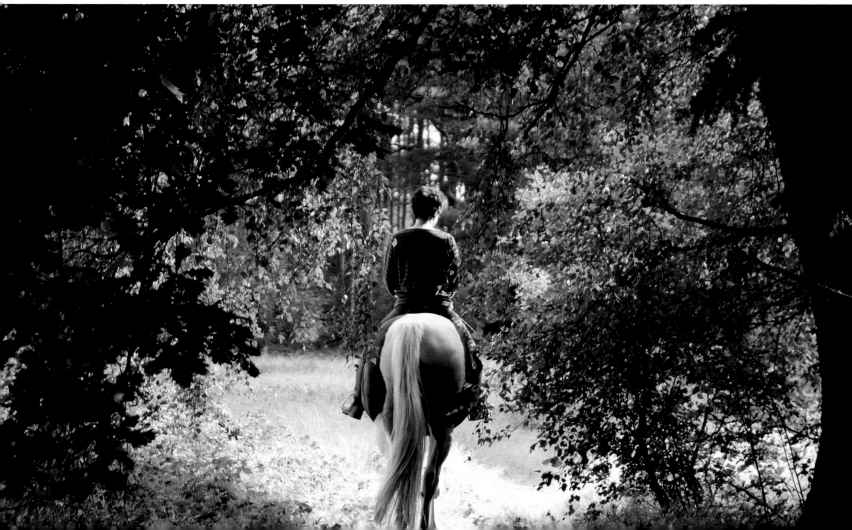

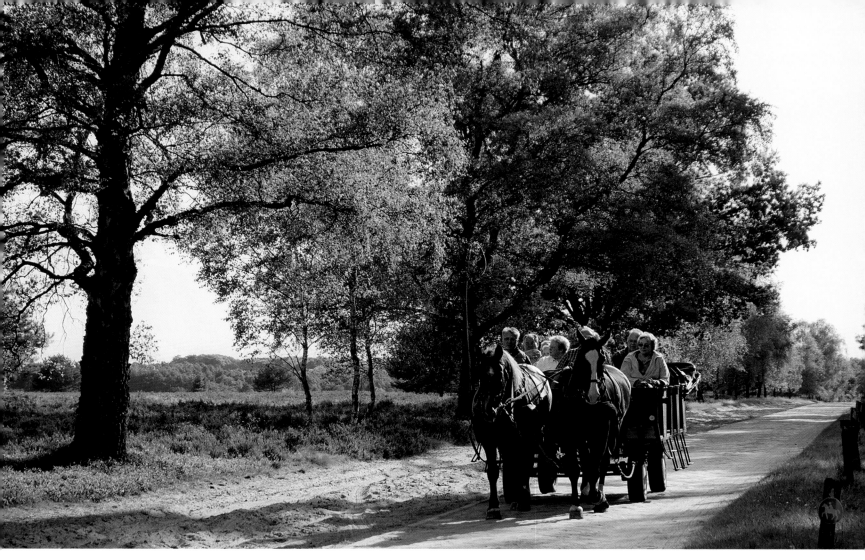

Above:
Travelling through the flowering heath on a horse and cart. Cars are banned in much of the national park to help protect the environment. Riding is also only permitted on specially marked bridleways.

Left and far left:
So that hikers and riders don't get lost there are plenty of useful waymarks: here on Wietzer Berg (far left) and near Wilsede (left).

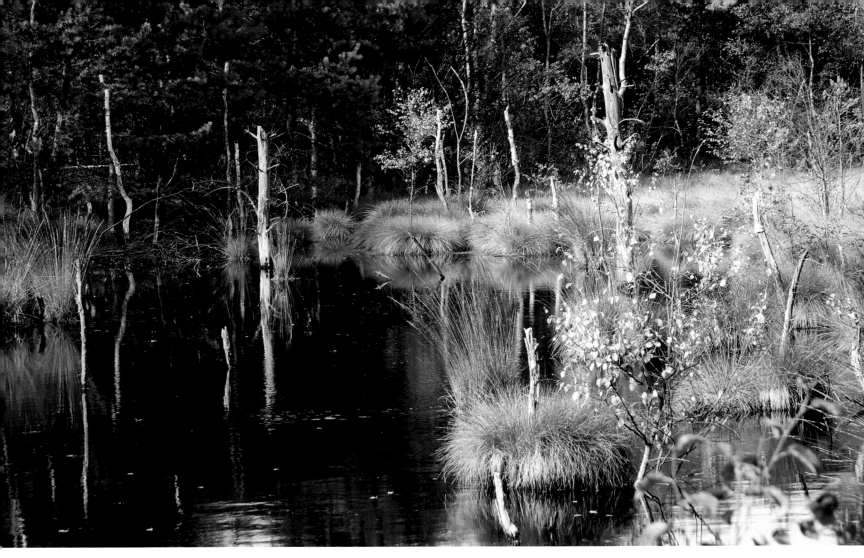

Above:
The largest moor on the Lüneburger Heide is Pietzmoor east of Schneverdingen. Peat was cut here until well into the 1960s.

Right:
Country barns and an omnipresent dwarf pine in the high moorland landscape of Pietzmoor, the long grass almost as dry as the thatch on the huge roofs.

Above:
*Undeloh on the Lüne-
burger Heide is popular,
especially with people in
and around Hamburg.
The Magdalenenkirche is
one of the oldest typical
heathland churches
and dates back to the
13th century.*

Left:
*Close to Oldendorf
southwest of Lüneburg
several graves from the
New Stone Age have been
found (from c. 4500 BC).*

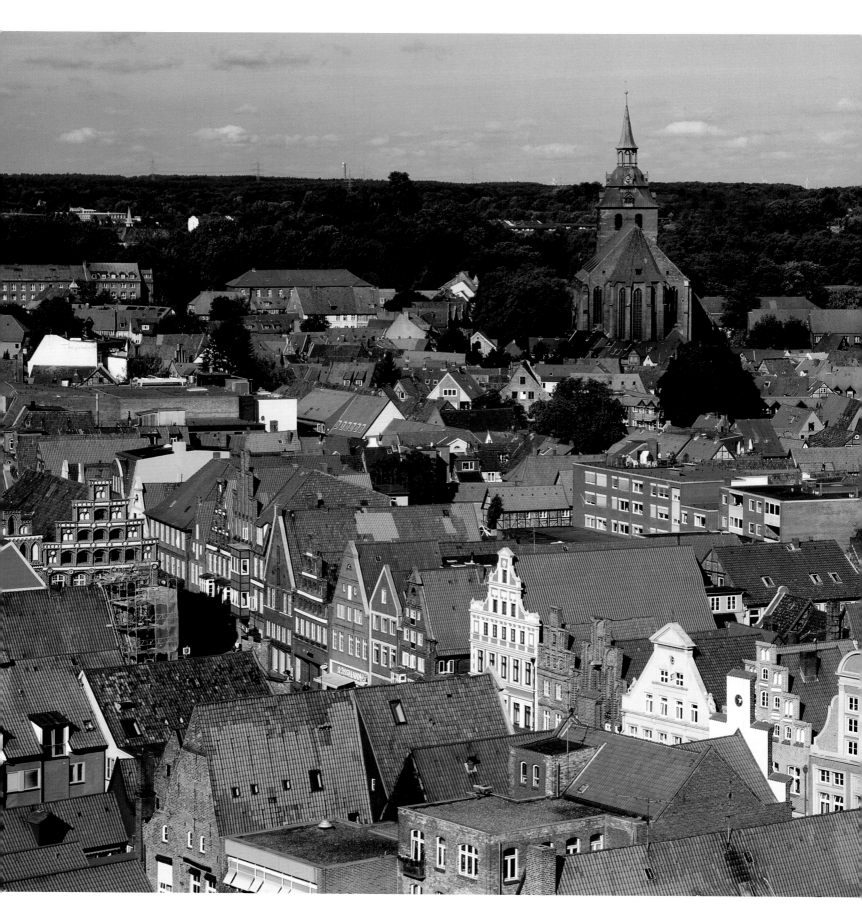

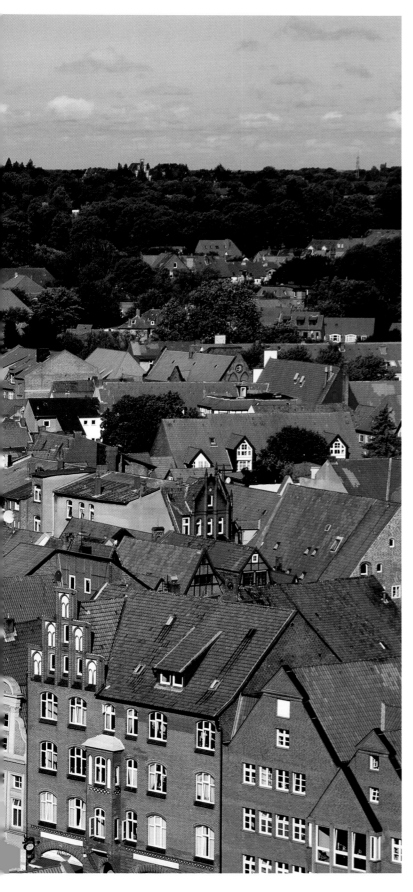

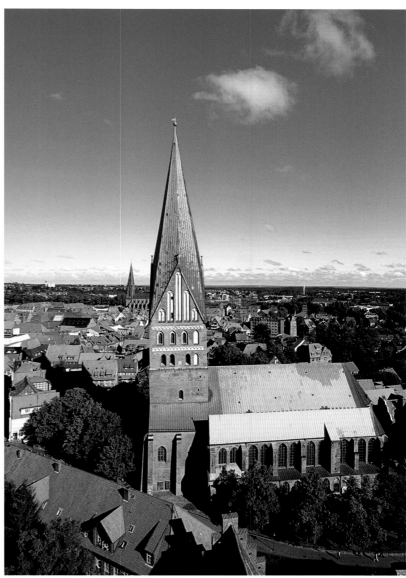

Left:
View out over the rooftops of Old Lüneburg. A member of the Hanseatic League, in the Middle Ages the town prospered from its rich yields of salt. Twenty thousand metric tonnes of 'white gold' a year were sent out from Lüneburg all over the world.

Above:
The church of St Johannis am Sande in Lüneburg with its tall, slightly crooked steeple is the oldest church in town. The Gothic hall church with a nave and four aisles was built between 1289 and 1470.

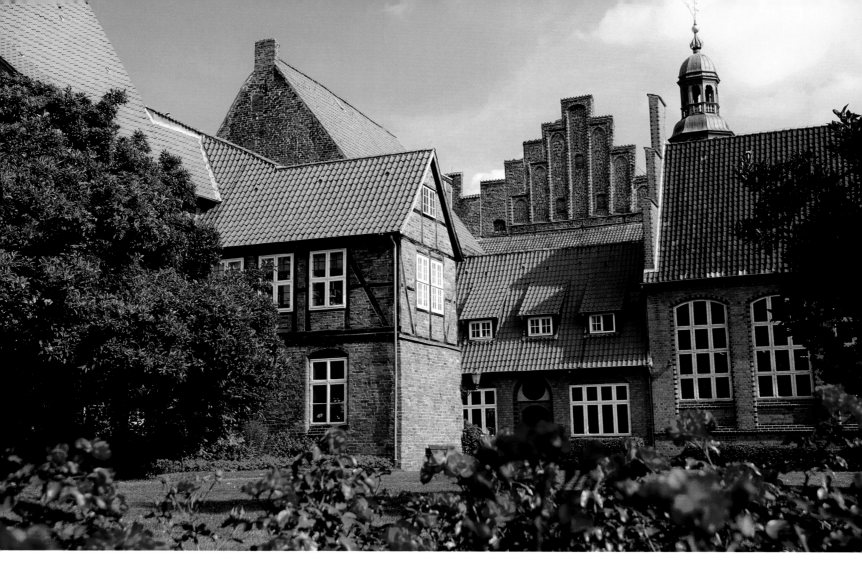

Above:
The garden of the town hall in the old town of Lüneburg. The historic centre was barley damaged during World War II.

Right:
Half-timbered houses in Lüneburg. Heinrich Heine, whose parents lived in Lüneburg from 1822 to 1826, called it his »residence of boredom«.

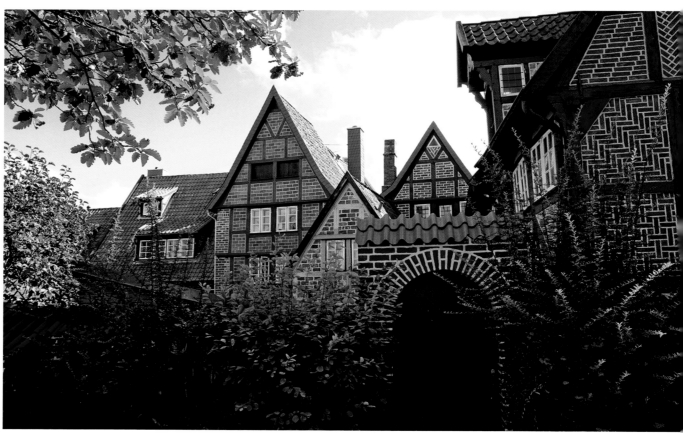

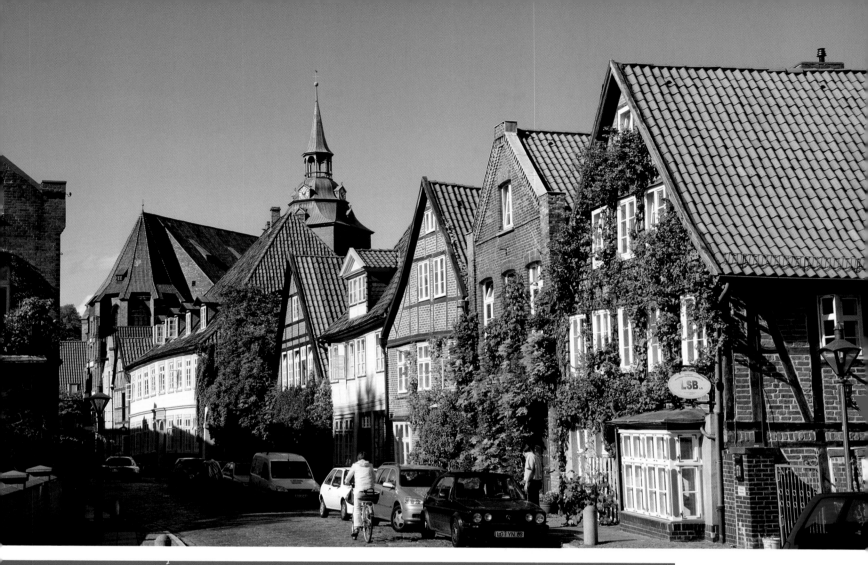

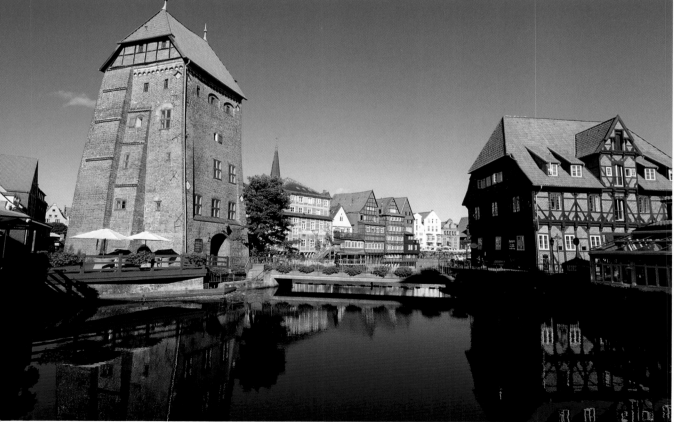

Above:
Houses in the old part of Lüneburg on Auf dem Meere, with the church of St Michaelis in the background. The young Johann Sebastian Bach sang here as a choirboy between 1700 and 1702.

Left:
The Lüner Mühle and Abtsmühle in the historic harbour quarter of Lüneburg are both from the 16th century. Grain was milled here until the 20th century.

From provincial capital Hannover to the Harz Mountains

Schloss Marienburg near Nordstemmen west of Hildesheim was the seat of the last king of Hannover. Blind King Georg V gave it to his queen Marie as a birthday present in 1857. The castle was rebuilt in neo-Gothic between 1857 and 1867 by Conrad Wilhelm Hase.

At the point where the hills of the Weserbergland peter out into the Norddeutsches Tiefland and at the intersection of a number of major European trade routes lies the provincial capital of Hannover, home to about half a million. Hildesheim, about 30 kilometres (19 miles) southeast of Hannover, is worth making a detour for. Its cathedral with the legendary rose on the apse and the Michaeliskirche are a UNESCO World Heritage Site.

The Braunschweiger Land covers the area between the Lüneburger Heide and the Harz Mountains. Sights not to be missed include Braunschweig itself, home to Henry the Lion, Wolfsburg with its Alvar Aalto buildings and Autostadt museum, the old royal seat of Wolfenbüttel and Salzgitter, where the Teutons once mined iron ore.

Attempting to come to terms with the former separation of Germany and opening up new perspectives for the future is the aim of the Grenzenlos or borderless project. Nowhere else in Germany is the history of East and West as authentic and palpable as in the Helmstedt-Marienborn region, where museums and memorials keep the memory of a divided nation very much alive.

The romantic, undulating scenery of the Weserbergland, part of which belongs to Lower Saxony, promises an interesting and varied journey. The Solling rises a proud 528 meters (173 feet) above sea level and offers plenty of activities. The River Weser meanders past a number of picturesque towns, among them Hameln (Hamelin), Bodenwerder and Holzminden.

The traditional university town of Göttingen in the foothills of the Harz, right in the south of the federal state, has many attractions worth investigating, from its wonderfully preserved historic centre to major museum collections to the famous jazz festival.

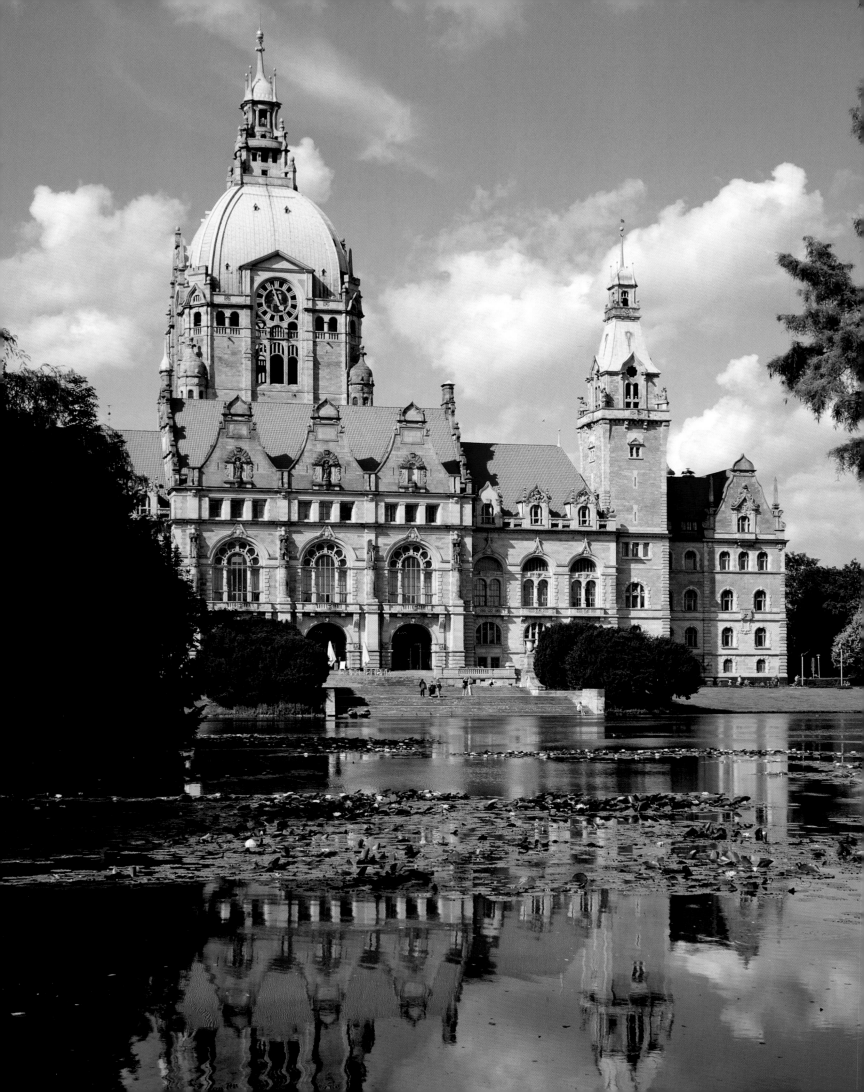

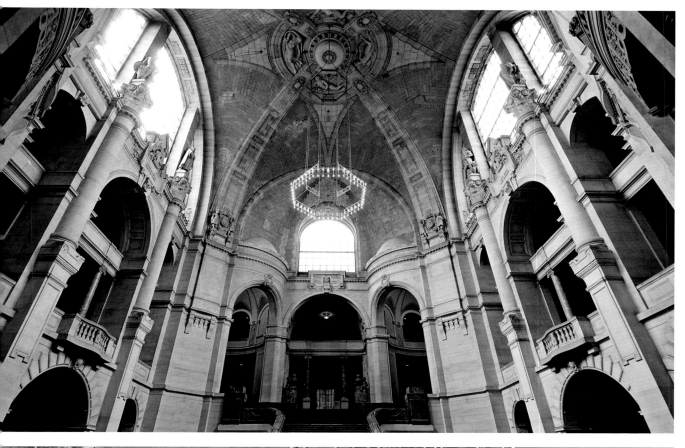

Left page:
The Neues Rathaus in Hannover is reflected in the Maschteich. More palace than town hall, the building was opened on June 20, 1913, after twelve years of building.

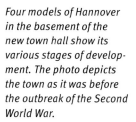

View of the dome of the Neues Rathaus. Including the viewing platform, it measures 100 metres (328 feet) in height. The cupola is accessed by a lift.

Four models of Hannover in the basement of the new town hall show its various stages of development. The photo depicts the town as it was before the outbreak of the Second World War.

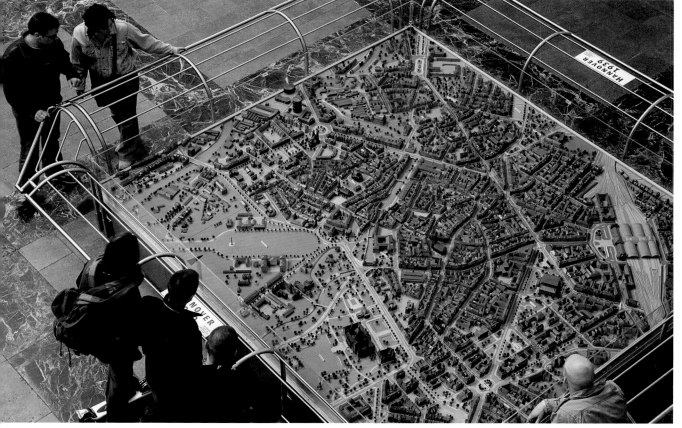

Right:

The Altes Rathaus in the heart of the old town in Hannover bears witness to the North German brick Gothic period. The building was begun in 1410. A local campaign prevented it from being torn down at the end of the 19th century.

Far right:

From 1698 until his death in 1716 Gottfried Wilhelm Leibniz lived in a Renaissance town house built in 1499. It was destroyed in 1943 and rebuilt with a copy of the original façade in another place – on Holzmarkt –between 1981 and 1983.

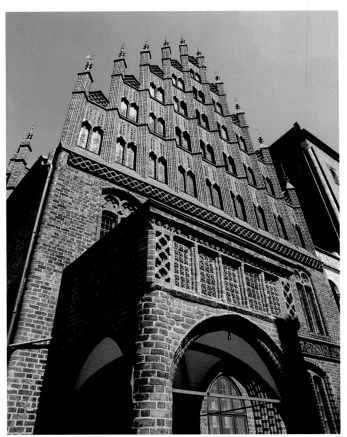

Right:

Ballhofplatz is named after the ballroom erected by Duke Georg Wilhelm between 1649 and 1664 as a functions room and for the then fashionable game of badminton. Small-scale concerts and plays take place on the square outside.

Right page:

Köbelstraße with the Altes Rathaus and the Marktkirche beyond. The oldest of the three parish churches in the old part of Hannover goes back to the 14th century.

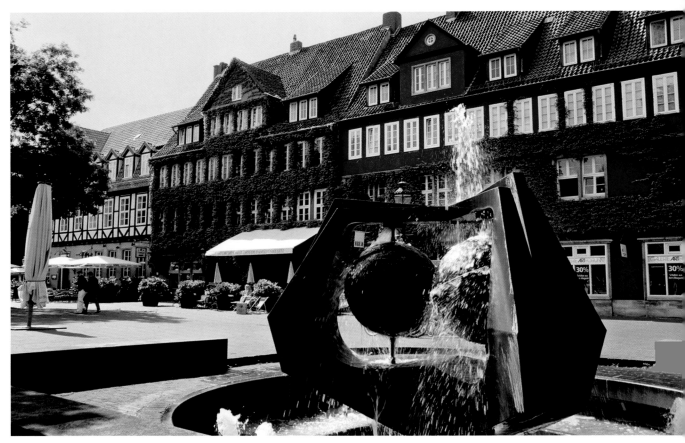

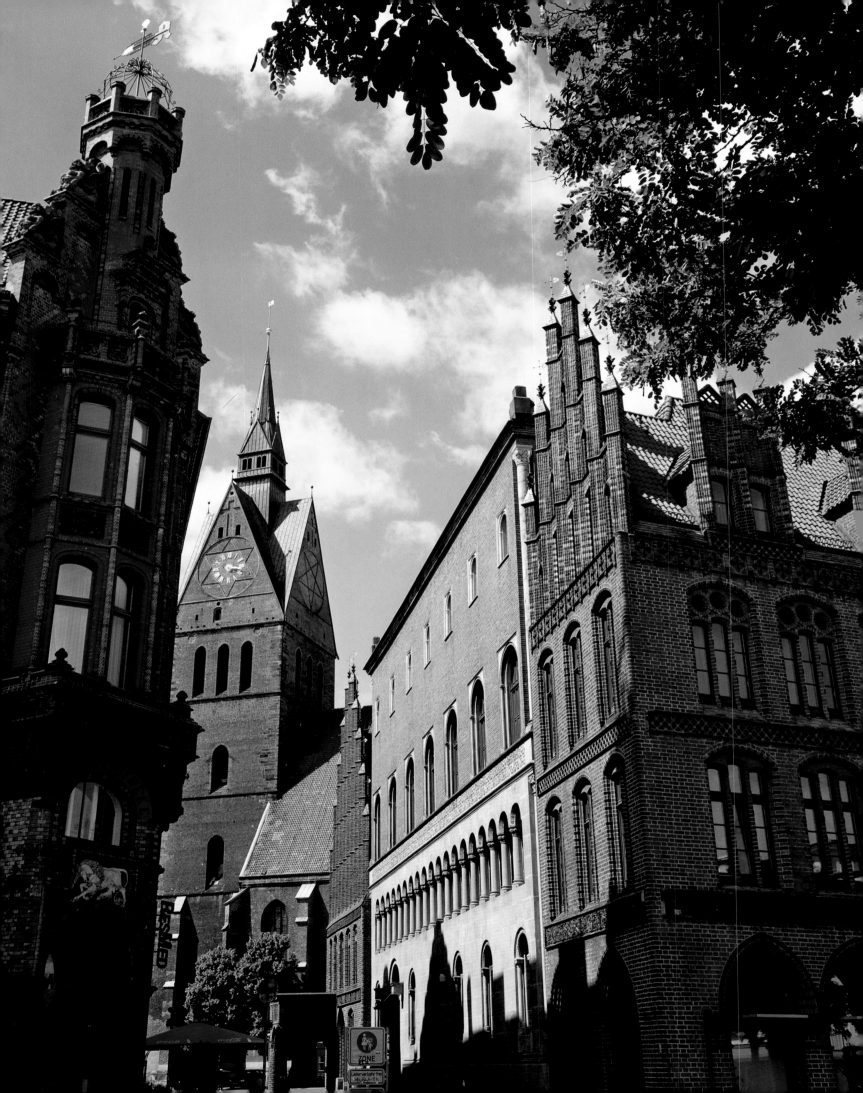

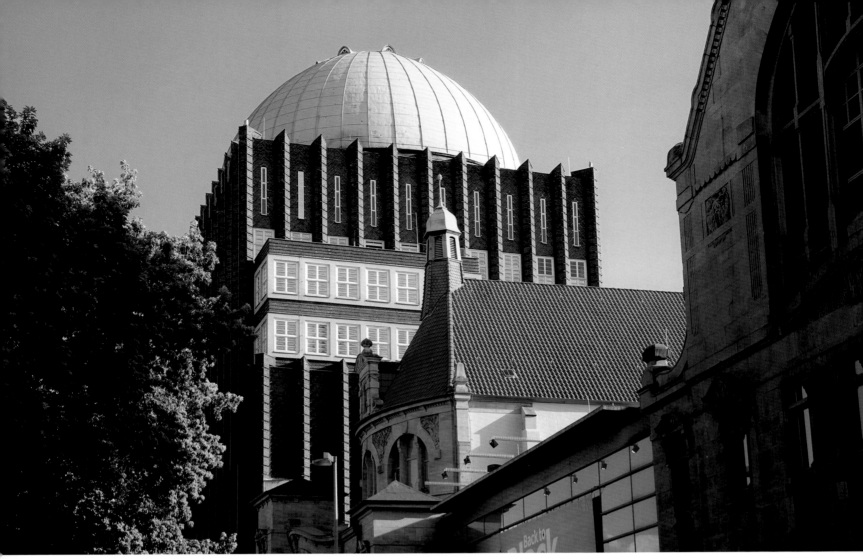

Above:
The huge Anzeiger-Hochhaus, its distinctive cupola a local landmark, was built in 1927/28 by Expressionist architect Fritz Höger (1877–1949).

Right:
This monument to The Göttingen Seven outside the state parliament building is by Italian Floriano Bodini (1933–2005). It depicts seven professors from Göttingen who protested against the lifting of the state constitution in 1837. They were removed from office for their pains and some even had to leave the country.

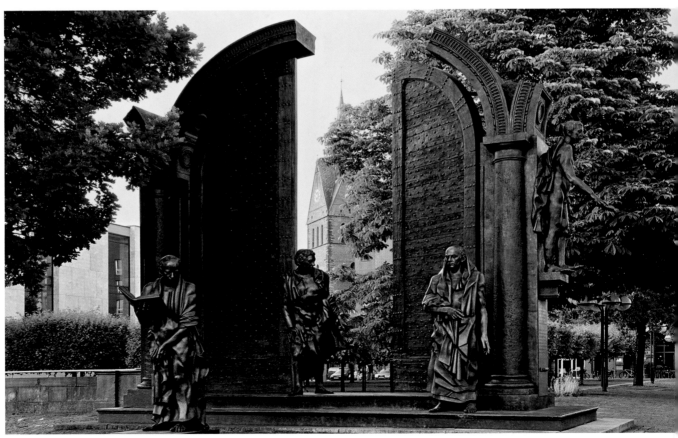

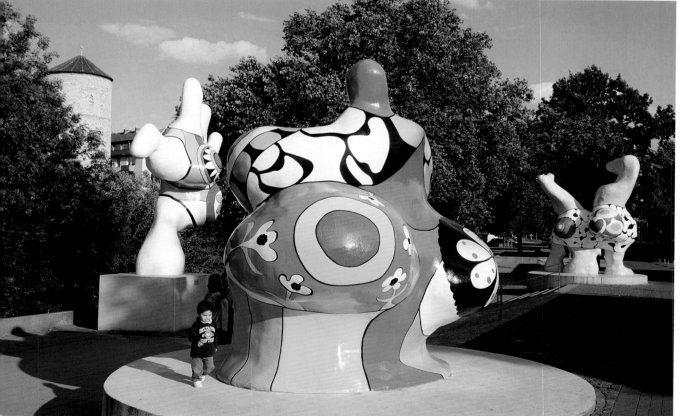

Above:
The neoclassical Laveshaus on Friedrichswall in Hannover was erected as the private home of royal architect, town planner and civil engineer Georg Ludwig Friedrich Laves between 1822 and 1824.

Left:
French artist Niki de Saint Phalle (1930–2002) was famous for her sensual, brightly coloured Nanas. These three adorn the mile of sculptures on the banks of the River Leine in Hannover.

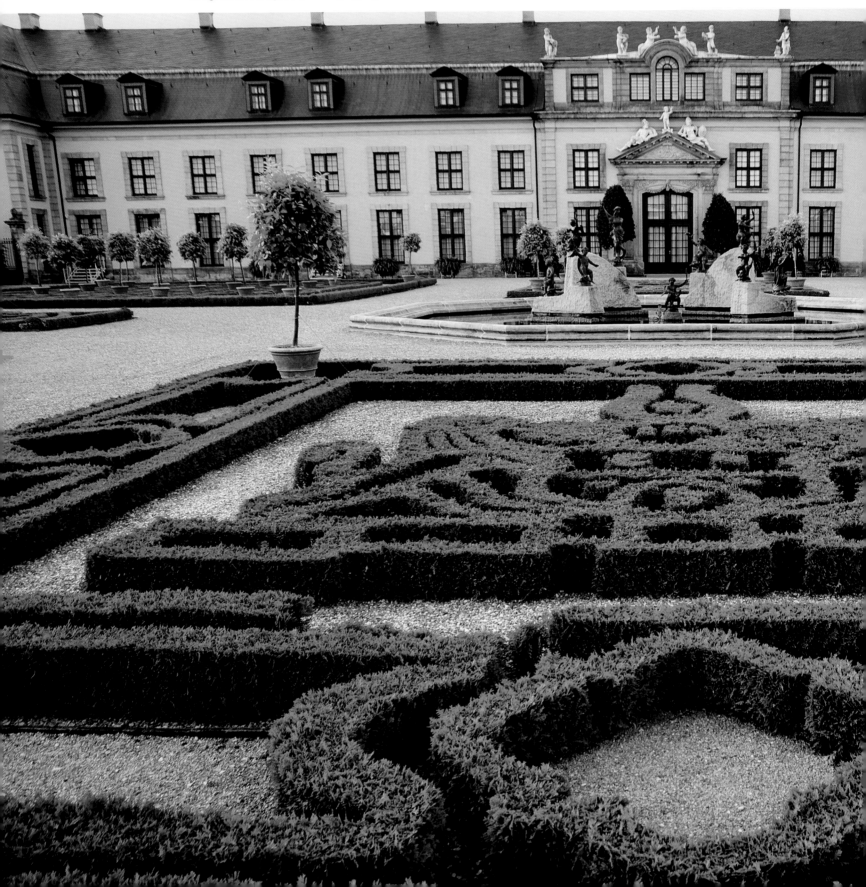

Below:
The Großer Garten at Herrenhausen is the historic centrepiece of the palace gardens. In the background is the gallery which is used as a venue during the Herrenhausen festival and also for receptions and other high-flying events.

Centre right:
Lit up in the soft light of
dusk: the great fountain
the Großer Garten with
its jet of water shooting
80 metres (260 feet) up
into the air.

Bottom right:
The Maschsee attracts
both water sports addicts
and hikers, cyclists and
joggers who happily make

use of the six kilometres
(four miles) of paths and
cycle tracks which run
along its shores.

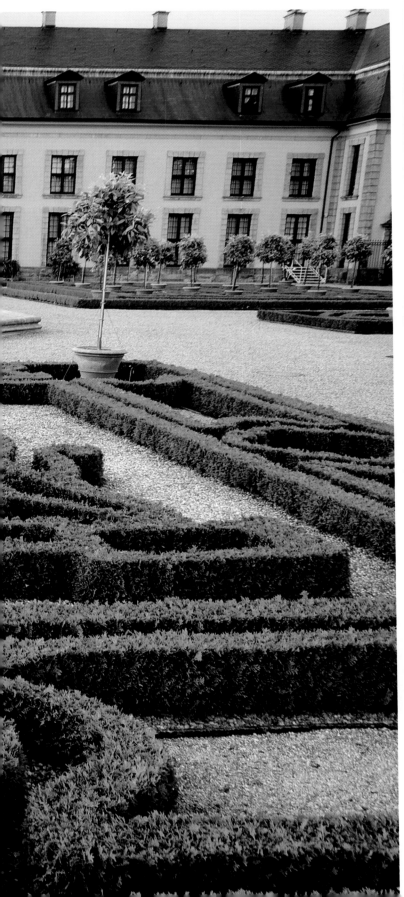

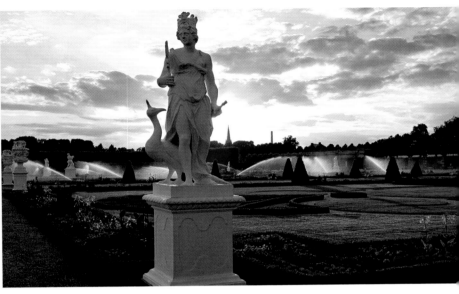

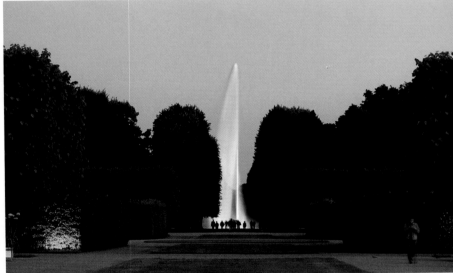

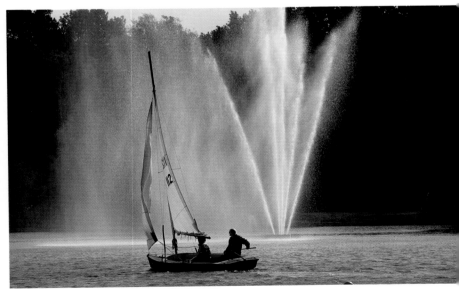

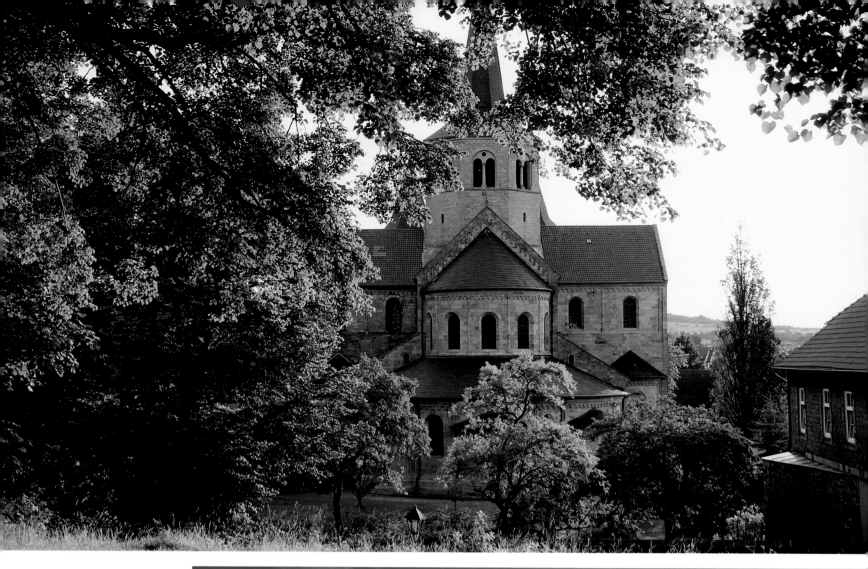

Above:

The basilica of St Gode-
hard in Hildesheim was
built in late Romanesque
during the 12th century on
the canonisation of
Benedictine abbot and
later bishop of Hildesheim
Godehard. Much of it
is original.

Right:

The cathedral of St Mary's
in Hildesheim. The first
cathedral to be built on
this site was 9th century;
all later edifices rest on
its foundations. The
thousand-year-old rose
bush near the apse is
legendary – and also the
town symbol of Hildes-
heim. The cathedral was
made a UNESCO World
Heritage Site in 1985.

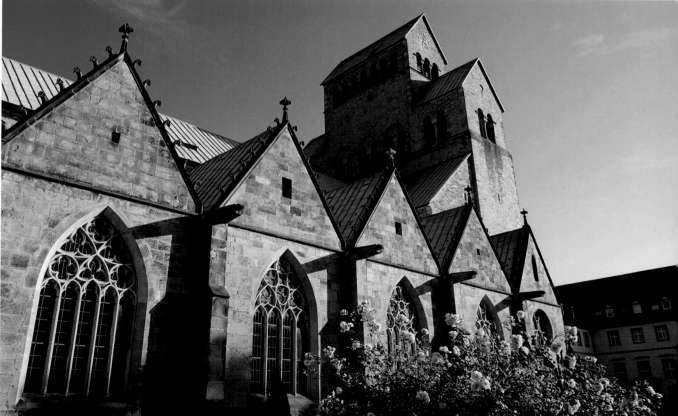

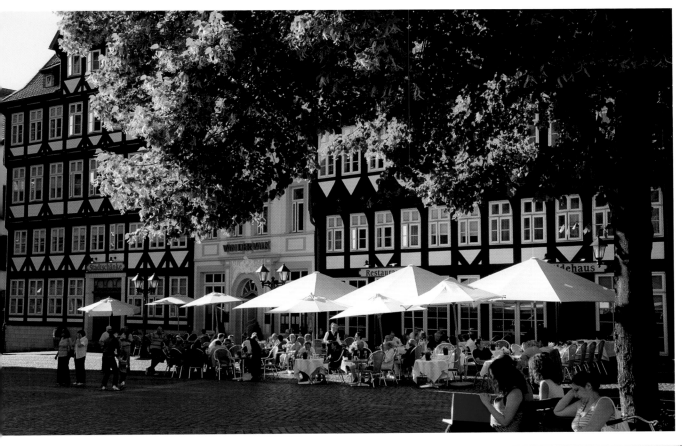

Left:
The half-timbered houses on the market place in Hildesheim are 1980s reconstructions. The historic square is now once again the epicentre of town for locals and tourists alike.

Below:
The Kehrwiederturm on Keßlerstraße is the last of four towers which once guarded the town defences of Hildesheim. Legend has it that it gets its name (the »return tower«) from the bell which once guided a noble lady lost in the forest back to the safe confines of the town defences.

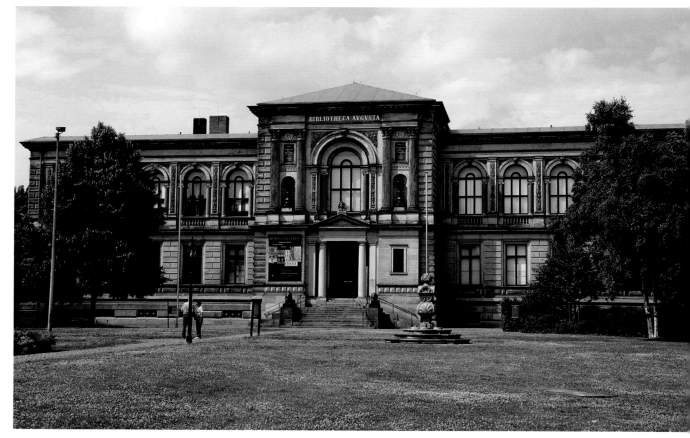

Right:
The Herzog-August-Bibliothek in Wolfenbüttel, also known as Bibliotheca Augusta, is a library and research facility of international repute. In the 17th century it was the largest library north of the Alps and heralded as the eight wonder of the world.

Below:
The Bibliotheca Augusta is where Gottfried Wilhelm Leibniz and Gotthold Ephraim Lessing once worked as librarians. Here, view of the Augusteerhalle.

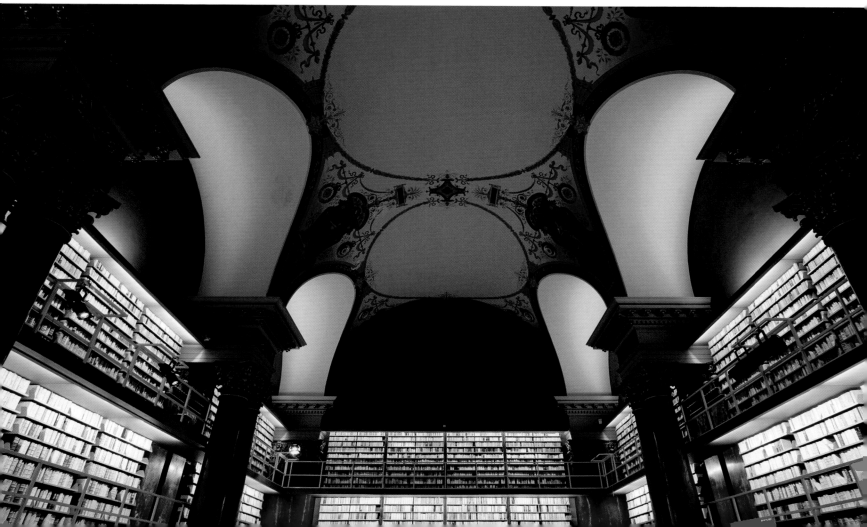

Above:
Statue of Duke August
the Younger (1579–1666)
on the market place in
Wolfenbüttel, erected in
1904. He was considered
one of the most educated
princes of his day.

Left:
The Lessinghaus in
Wolfenbüttel. It was built
in 1733 in the style of a late
baroque French garden
house and used by court
officials. It was allotted to
Gotthold Ephraim Lessing
as a place of residence
in 1777, where he lived
and worked until he died.
The villa is now a Lessing
museum.

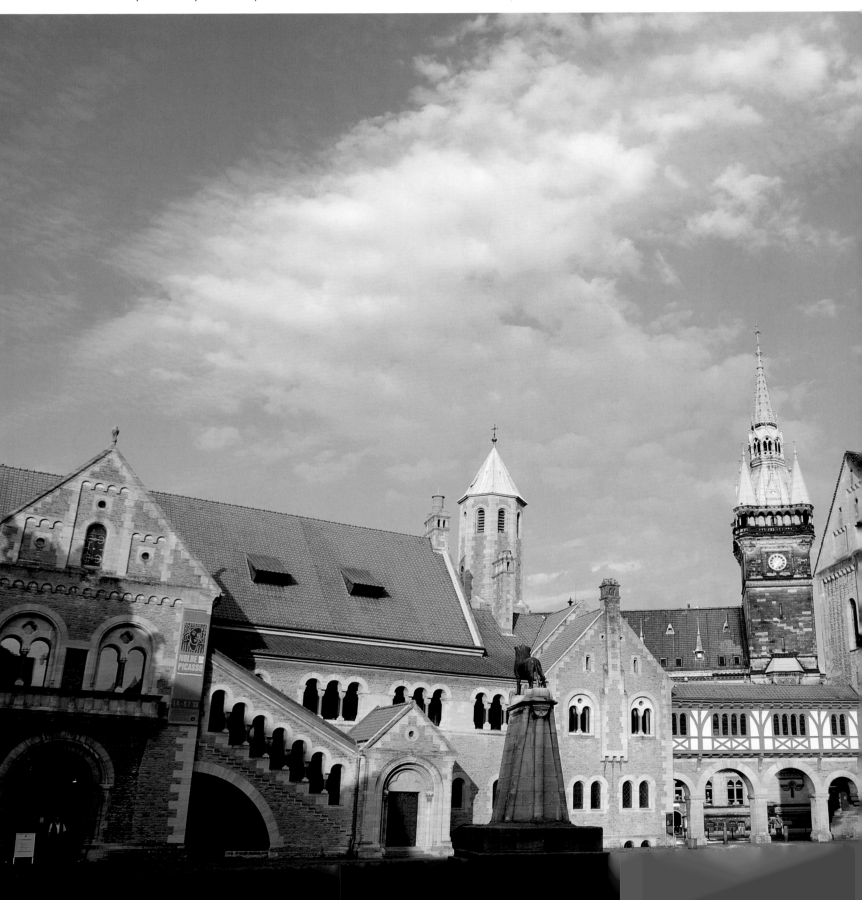

Below:
Burg Dankwarderode on Burgplatz in Braunschweig goes back to the 11th century and for centuries was home to the dukes of

Brunswick. The castle is now part of the museum named after Duke Anton Ulrich where the original city lions are kept.

Top right:
The market place in the old town is the beating heart of historic Braunschweig. The Gothic Altstadtrathaus is one of the oldest town

halls in Germany which is still standing. The oldest section dates back to the mid 1200s. The fountain outside it is from 1408.

Centre right
In the great hall of Burg Dankwarderode It was badly damage during the Second Worl War, extensively restore

during the 1990s and is now used for events and exhibitions. The original wall paintings have been painstakingly recreated.

Bottom right: In the Magniviertel, one of the oldest quarters of Braunschweig, life is sedately busy as people wander in and out of the many pubs and cafés. The first weekend in September sees the event of the Magnifest – a huge street party with plenty of entertainment and a market to enjoy.

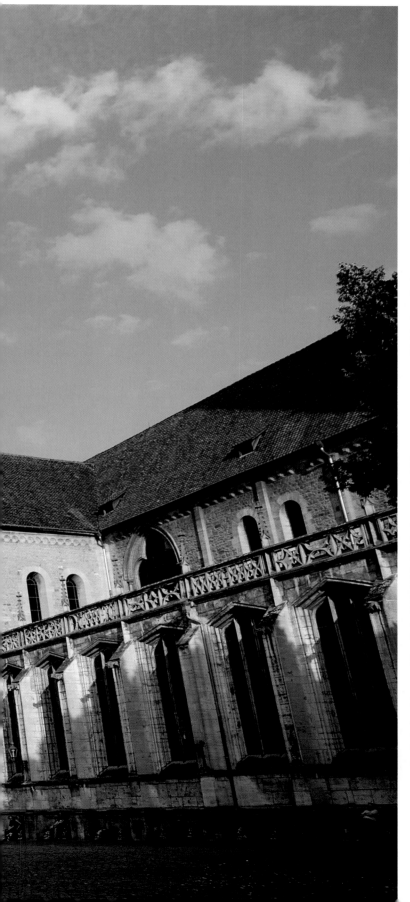

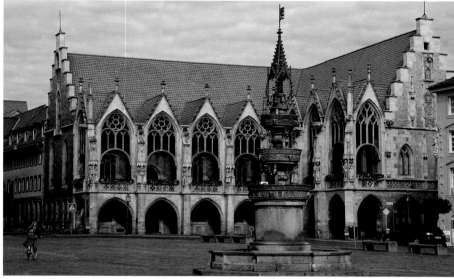

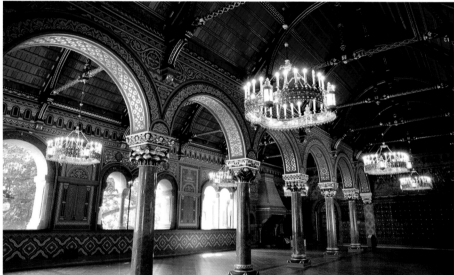

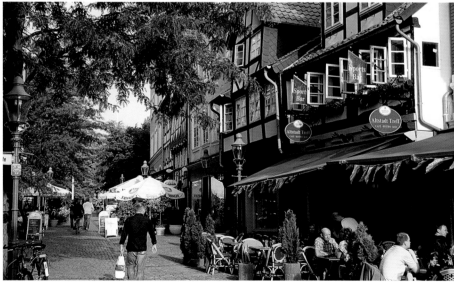

Motoring history – the Volks- wagen from Wolfsburg

The past is tangible. Memories are awakened. Emotions are stirred. And the typical jet-like burbling of a Beetle flat-4 engine is back in your ears. Hearts beat faster – both young and old.« These aren't just words – used by Volkswagen in Wolfsburg to describe its museum exhibits. For many, they are a credo. The Volkswagen Beetle or *Käfer* wasn't just any old car; for many Germans it was their first car and their self-issued passport to mobility and freedom. A certain degree of nostalgia and sentimentality is thus allowed – as are the bugs of the idiosyncratic Bug, such as the heating with a mind of its own and the rather pathetic 6 V headlamps of the early years …

The name Volkswagen has long been synonymous with »global concern«. Europe's biggest car manufacturer, Volkswagen AG, is now a subsidiary of Porsche and includes Audi, Bentley, Bugatti, Lamborghini, Seat, Škoda and Scania. In the financial year 2006 Volkswagen delivered 1.1 million vehicles in Germany alone, amounting to a market share of 30%. Worldwide this figure is 10%.

It all started with the prototype *Volkswagen* or people's car. In January 1934 at the International Motor Show (IAA) in Berlin, German Chancellor Adolf Hitler demanded that a car be constructed to cater for wide sections of the population. It was to have four seats, be able to cruise at 100 kilometres (60 miles) per hour, be economical to run and cost under 1,000 Reichsmarks. As all other automobile manufacturers dismissed the plan as not feasible, engineer Ferdinand Porsche was commissioned to design the *KdF-Wagen*. Austrian constructor Béla Barényi (1907–1997) is now heralded as being the actual maker of the *Käfer*.

Biggest car factory in the world

»KdF« stands for »Kraft durch Freude« or strength through joy, the name of a subdivision of the Deutsche Arbeitsfront (DAF or German Labour Front) responsible for organising the German people's leisure time and »bringing it into line«. In 1938 Hitler laid the foundations for the factory where 150,000 cars a year were supposed to be built. The site was a rural, sparsely populated stretch of land near Fallersleben and Schloss Wolfsburg. Easy to access at the geographical centre of the Third Reich, the DAF soon erected the biggest car factory in the world, with everything financed by funds confiscated from the unions. On July 1, 1938, a town was also founded here and given the bureaucratic designation of Stadt des KdF-Wagens

bei Fallersleben or the city of the KdF car near Fallersleben.

The public were duly promised the car at 990 Reichsmarks although it soon became clear that the cost of manufacture would amount to over twice this. Each week, 340,000 Germans conscientiously bought savings stamps for five marks each, sticking them onto special cards. They were all cheated out of their money; when the Second World War broke out in 1939 production went military, churning out war machines such as the *Kübelwagen* or Bucket / Tub Car. 20,000 forced labourers were brought in. Decades later the concern was to pay them compensation and become a pioneer in the reparations made by the German economy.

In 1945 Stadt des KdF-Wagens, where 17,000 people had since made a home, was renamed Wolfsburg and under the British occupying forces the production of the Volkswagen went into series. By the end of 1953 the car was being exported to 88 different countries. In August 1955 the millionth vehicle rolled off the production line. 20.5 million had followed it by 2003. Volkswagen Beetles were made in Germany up until 1978 when production was concentrated solely on Mexico and Brazil. The successor of the Beetle and the next real »people's car« was the VW Golf, since 2002 the most-bought car in Europe with 25 million sold.

Volkswagen makes 25,000 cars a day at 44 sites in 18 countries. The success of the Lower Saxon automobile manufacturer is documented at the Autostadt museum which was opened in Wolfsburg in 2000. Customers come here to pick up their new cars or to study the VW range close to. Laid out like a lagoon, the museum has many attractions; according to the concern, its exhibitions, works of art and films invite visitors to journey into the world of mobility.

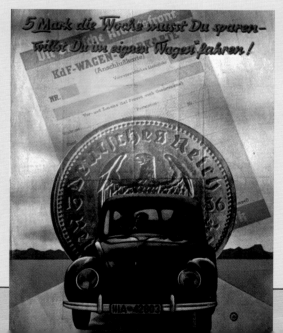

Left:
Savings stamps for KdF cars were stuck onto cards like these. They were worthless by the end of the war.

Above:
Autostadt Wolfsburg was created in 2000 as part of Expo 2000 and is works museum and theme park rolled into one.

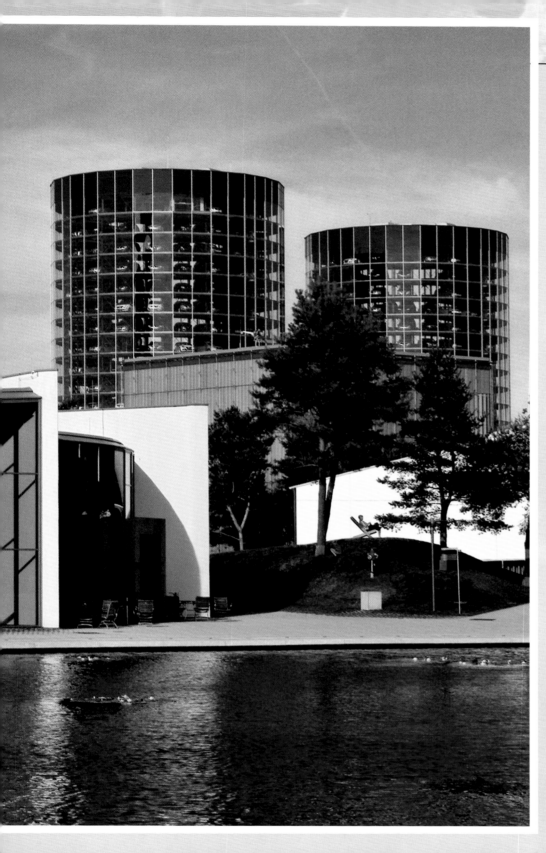

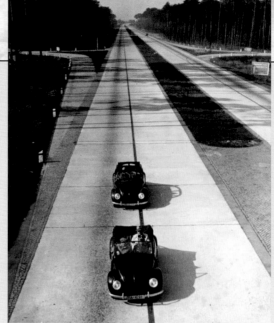

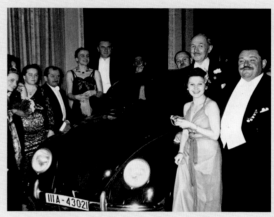

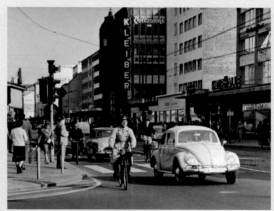

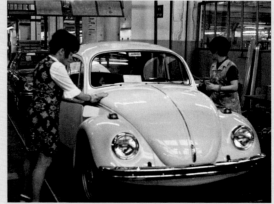

Right, from top to bottom: Two KdF cars cruising along the Reichsautobahn in January 1943, the only cars on the motorway!

On January 28, 1939, at a gala dinner for the press. The star of the show (a Volkswagen) is surrounded by a number of other big names, among them Ferdinand Porsche and actor Heinrich George.

The Sixties wouldn't be the Sixties without the VW Beetle! Here it's shown chugging through the streets of Karlsruhe in 1961.

It just kept selling – and selling and selling. Being given a final polish at the end of the production line in Wolfsburg in 1973.

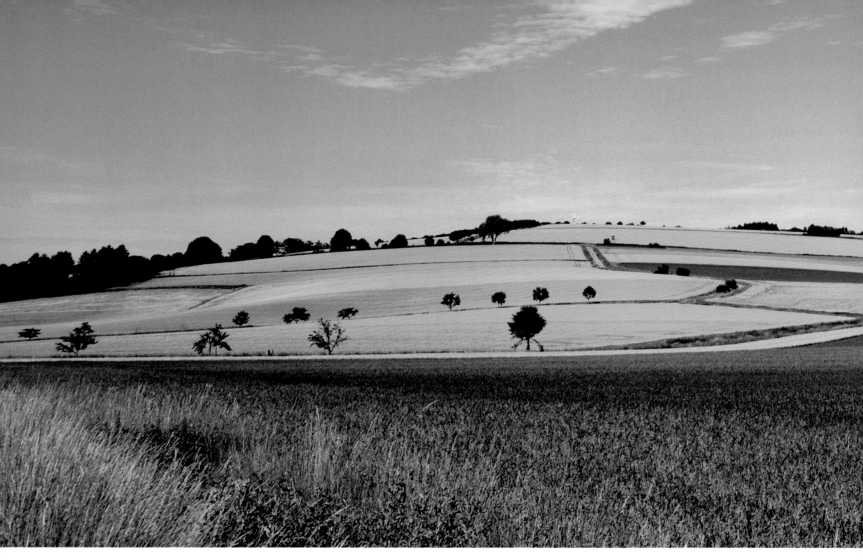

Above:
Countryside in the Naturpark Solling-Vogler in the Weserbergland. The park is northwest of Göttingen and covers 52,000 hectares (ca. 129,000 acres) of land between the Weser in the west and the Leine in the east. Rare birds and plants can be found here.

Right:
Cycling along avenues of ancient trees along the peaceful banks of the River Weser in the national park, not a hill or even a slight bump in sight – what could be better?!

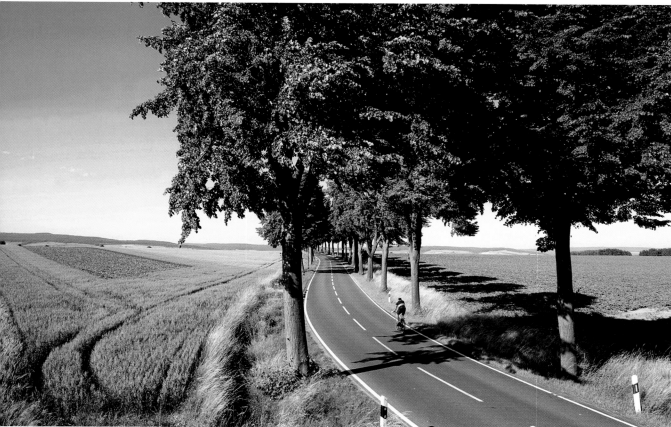

Left:
In January 2007 the Weserradweg was named Germany's most popular cycle track at the CMT tourist fair in Stuttgart. It's also perfect for less experienced cyclists.

Below:
The Weserbergland was home to the famous Weser Renaissance between 1520 and 1640. One example of this style of building is

Schloss Hämelschenburg, its Renaissance fabric completely preserved and elegantly sited in glorious surroundings between Hameln and Bad Pyrmont.

Top right:
The traditional porcelain manufacturer's at Schloss Fürstenberg was founded by Duke Carl I of Braunschweig in 1747 and is one

of the oldest in Europe. The restored palace in Weser Renaissance now houses the factory's own museum of bone china.

Centre right:
Kloster Bursfelde is in the rural district of Göttingen on the northeastern edge of the Naturpark Münden.

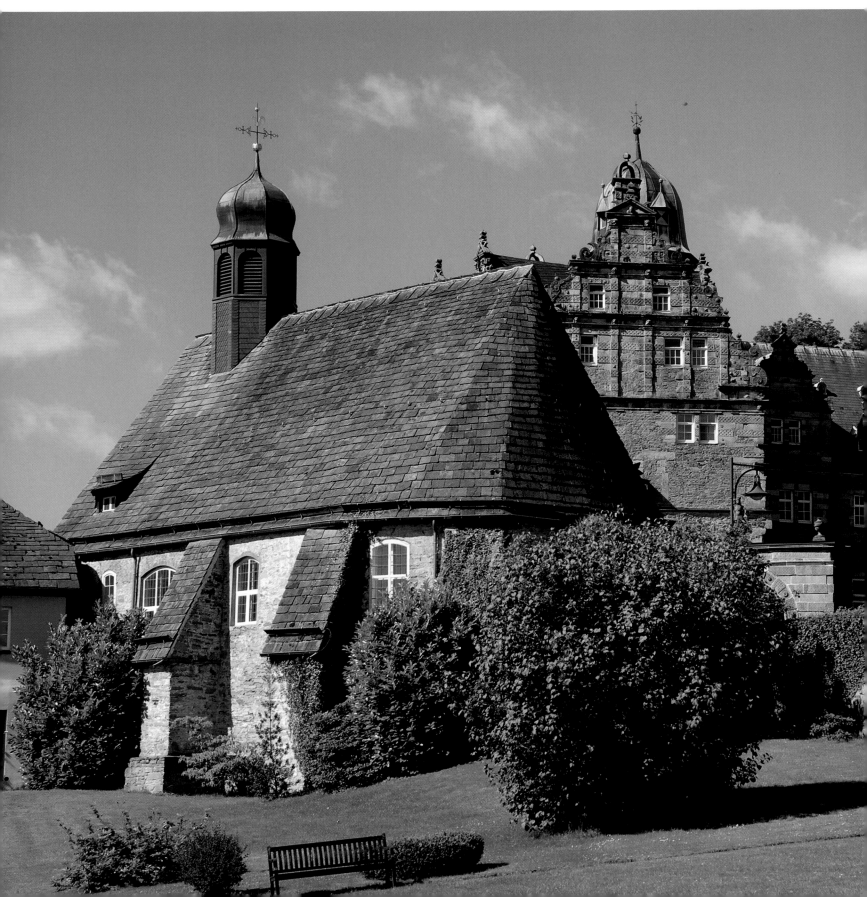

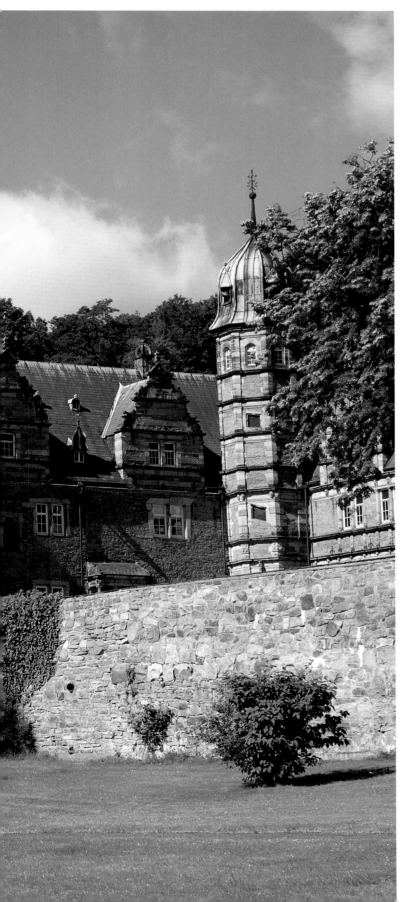

The chief building from the Romanesque to have survived is the monastic church dedicated to Thomas and St Nicholas.

Bottom right: *The little town of Boden-werder in the district of Holzminden is famous as the birthplace and dwelling of 'liar baron'*

Karl Friedrich Hieronymus von Münchhausen. The Schulenburg, part of his former estate, is now a museum devoted to von Münchhausen.

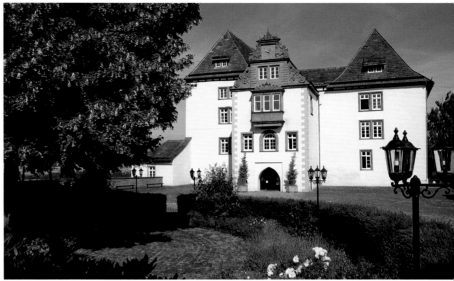

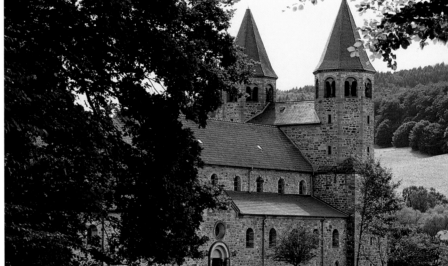

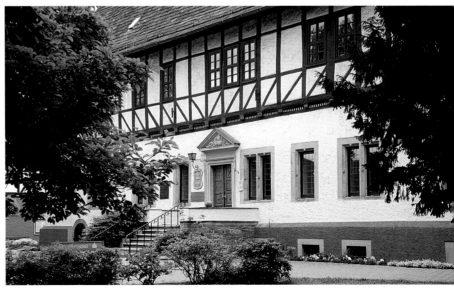

123

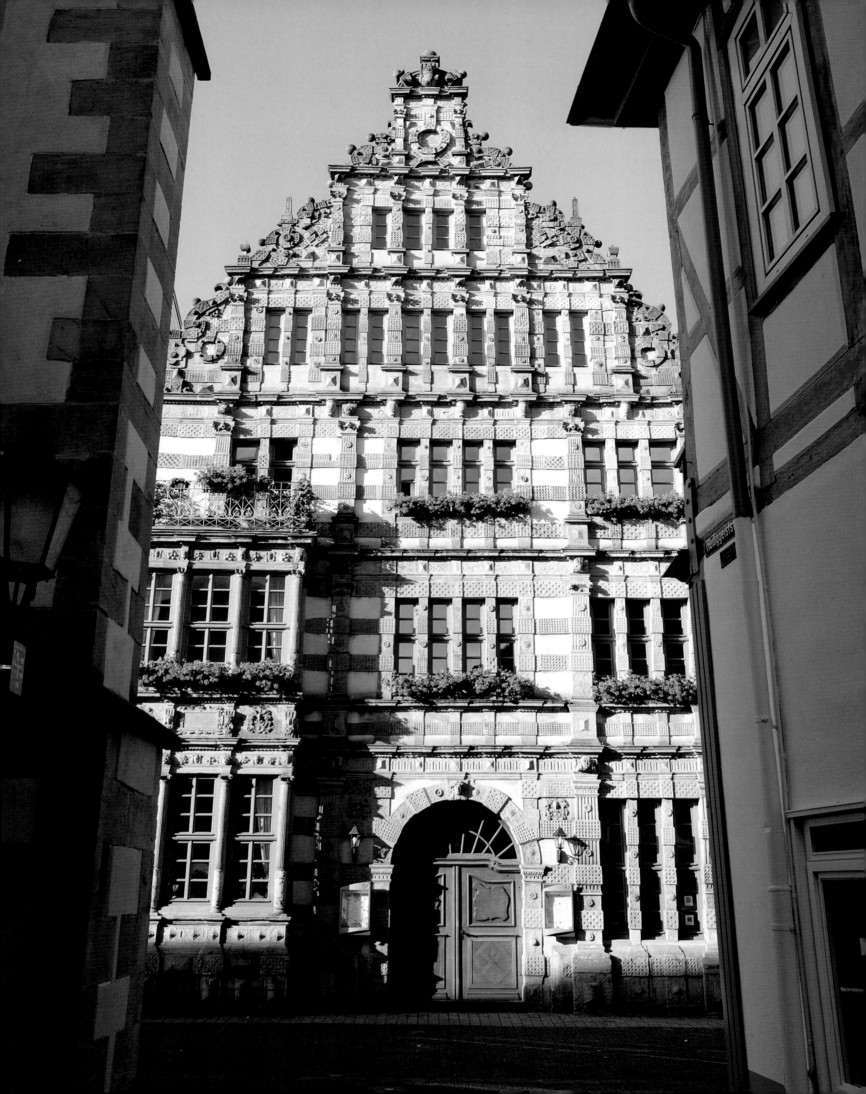

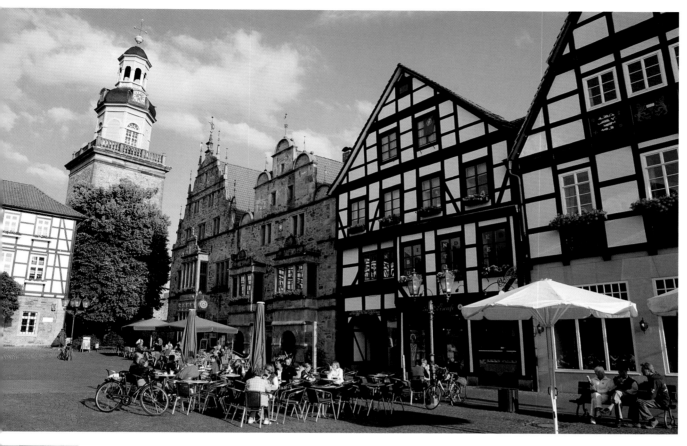

Left page:
The house of the Pied
Piper in Hameln, built in
Weser Renaissance in
1602. The story of the rat
catcher and children stealer
goes back to 1430–1450.

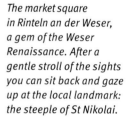

The market square
in Rinteln an der Weser,
a gem of the Weser
Renaissance. After a
gentle stroll of the sights
you can sit back and gaze
up at the local landmark:
the steeple of St Nikolai.

In the centre of Hanno-
versch Münden stands the
Rathaus, with a Gothic hall
from the 14th century at
its core. It was refurbished
by Georg Crossmann of
Lemgo between 1603 and
1618 when it was given its
present ornate façade. The
north front has a glocken-
spiel whose figures depict
scenes from the life of
Dr Eisenbarth, a prolific
local physician buried in
the Aegidienkirche.

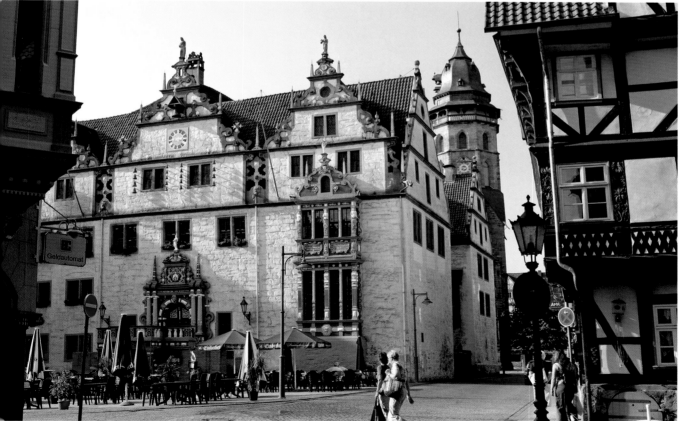

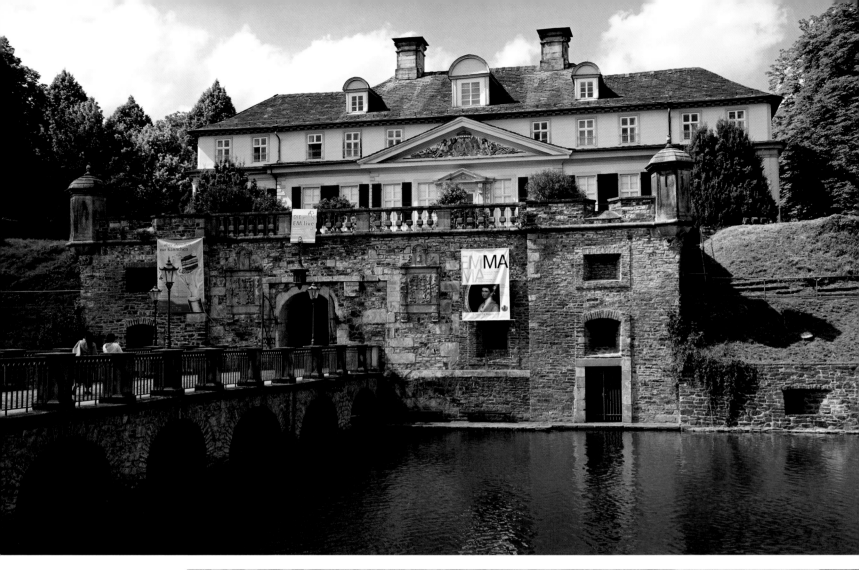

Above:
Bad Pyrmont is in the Weserbergland between Hameln and Paderborn. The baroque moated castle was once the main ward of a fortress from the 16th century. It's now a museum of the history of the town and spa.

Right:
The hilly national park of Münden gently undulates from the Weser to the Leine between Göttingen and Kassel. Large areas of forest and the rivers of the Werra, Fulda and Weser lend the countryside its serene beauty.

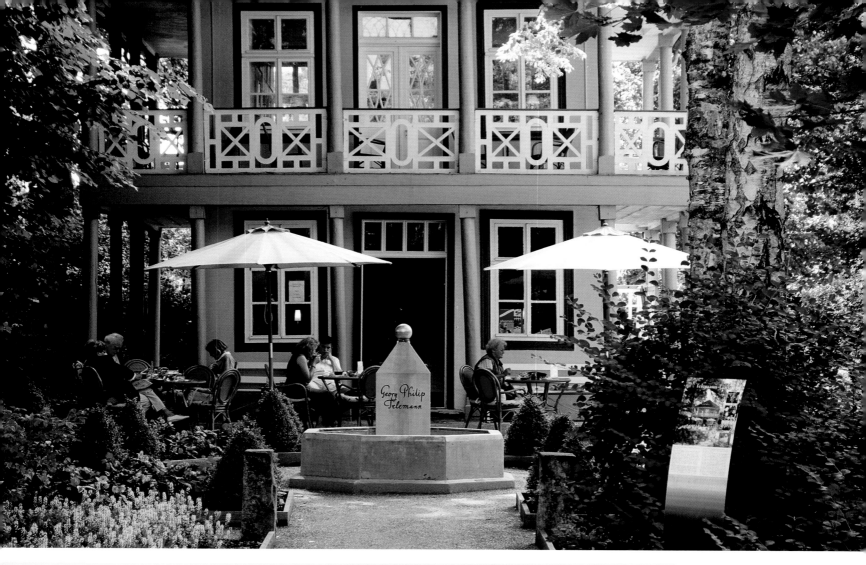

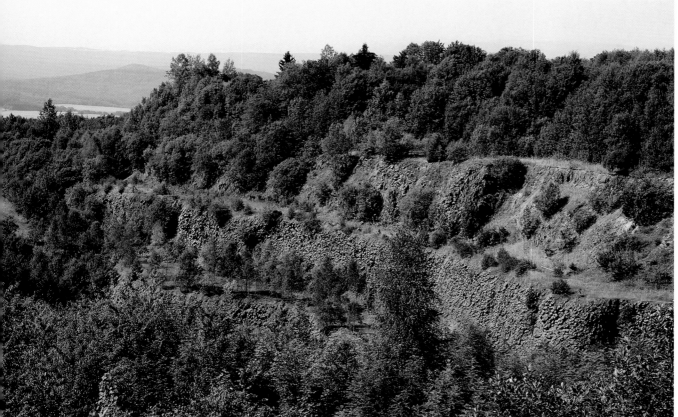

Above:
The Kurpark in Bad Pyrmont was made Germany's Most Beautiful Park in 2005. The Telemann Garden is devoted to composer Georg Philipp Telemann who took the air of Pyrmont on several occasions. Tea is most elegantly drunk under shady limes and planes at the park's Teehaus.

Left:
The old quarry in the Naturpark Münden. Basalt was quarried here from 1825/26 onwards, with activities only stopped in 1971.

127

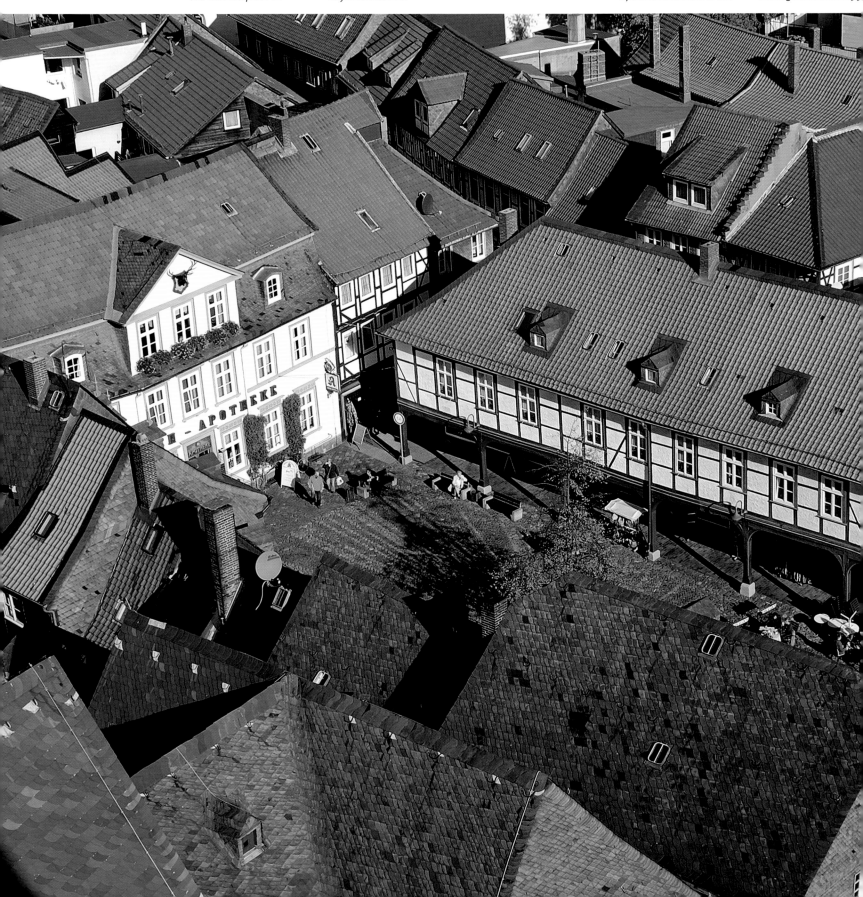

Below:
View of the medieval old town of Goslar from the north tower of the Marktkirche. Schuhhof, the oldest square in Goslar, is framed by an ancient apothecary's from 1780 (the Hirsch-Apotheke) and the guildhall of the city shoemakers.

Top right:
Sipping coffee on Schuhhof, with the two belfries of the Marktkirche in the background. The old tow and Rammelsberg ha been a UNESCO Wo Heritage Site since 199

Centre right:
...llic scenery on the edge ...he Harz near Bad Lauter-berg, with the medium-range mountains of the Harz in the background.

Bottom right:
Schloss Herzberg in Herzberg am Harz is one of the few castles in Lower Saxony which is half timbered, rebuilt

after a fire in 1510. It was owned by the Welf dynasty from 1158 to 1866 and is thus also known as the Welfenschloss or palace of the Welfs.

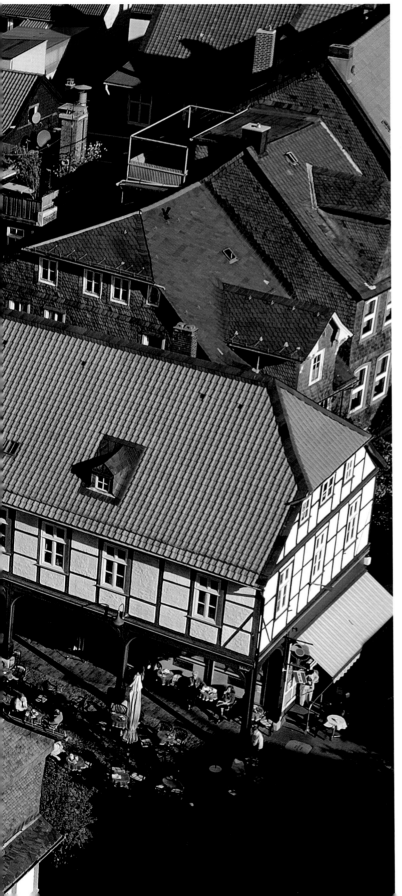

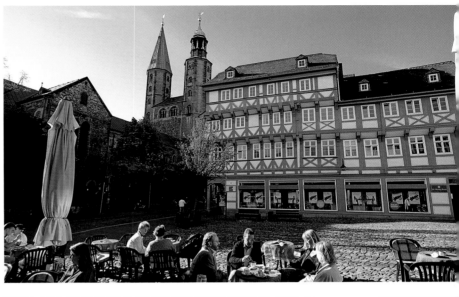

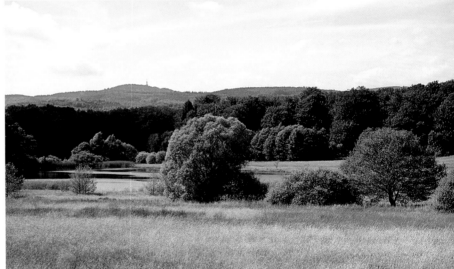

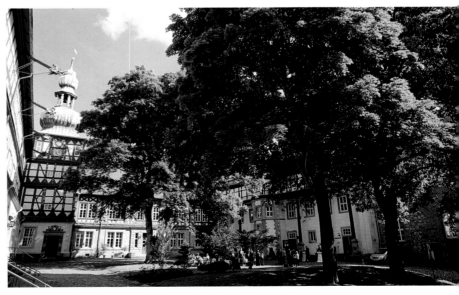

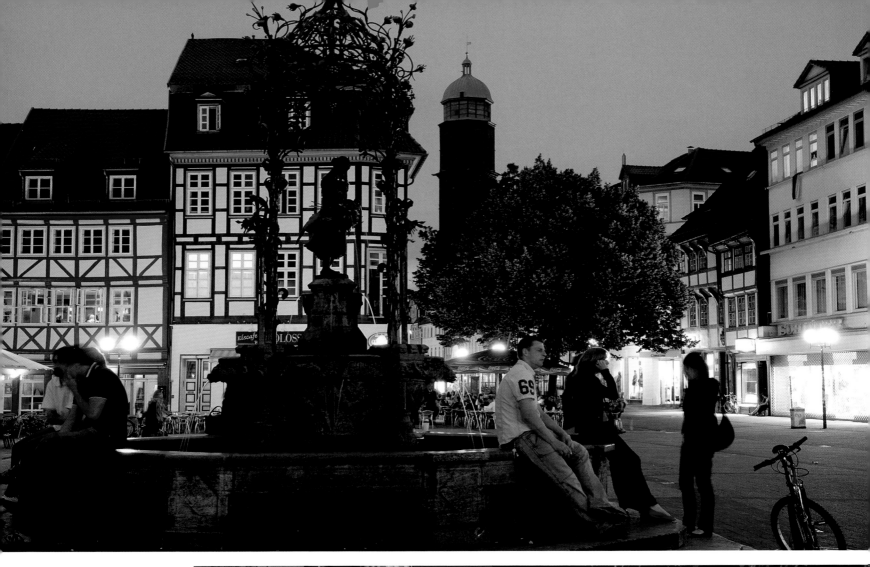

Above:
Dusk in the old university town of Göttingen, here on the market place from 1901 with Gänseliesel. The statue of the little girl and her goose is much loved, for according to an ancient custom everyone who's just passed their PhD has to give her a kiss!

Right:
Göttingen's popular shopping street, Weender Straße. Heinrich Heine wrote of the town »The city of Göttingen, famous for its sausages and university, belongs to the kings of Hannover and has 999 fireplaces, various churches, a maternity hospital, an observatory, a detention cell, a library and a restaurant under the town hall where the beer is very good.«

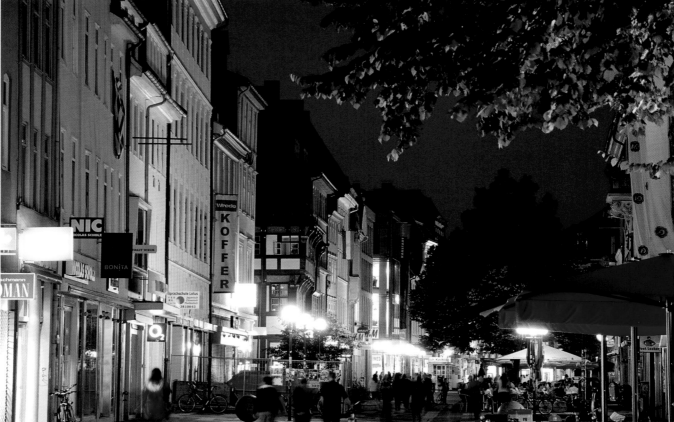

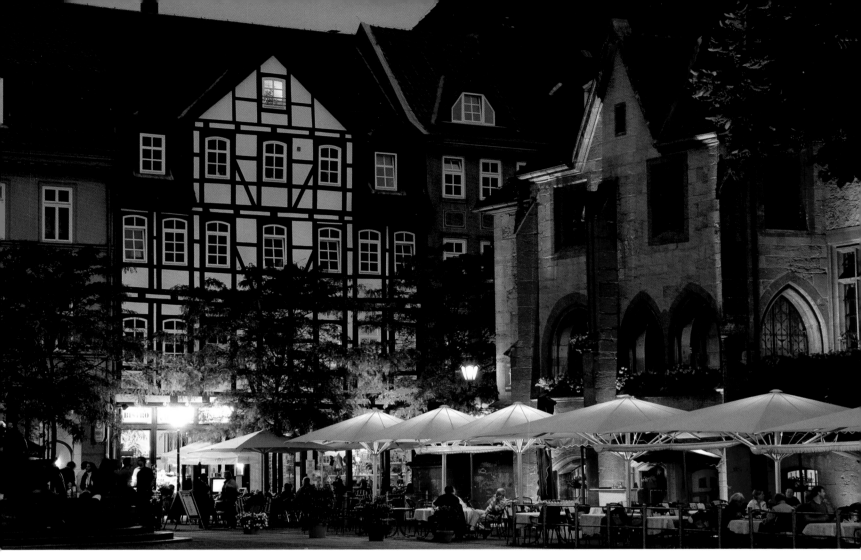

Above:
The Altes Rathaus in Göttingen on the west front of the market place was built in 1270. Over the course of its history it was refurbished, destroyed and rebuilt several times. Until 1978 it was home to the town administration and is now used as a prestigious venue for various activities.

Left:
The Gothic St-Johannis-Kirche with its two steeples is one of Göttingen's local landmarks. It was constructed between 1300 and 1344.

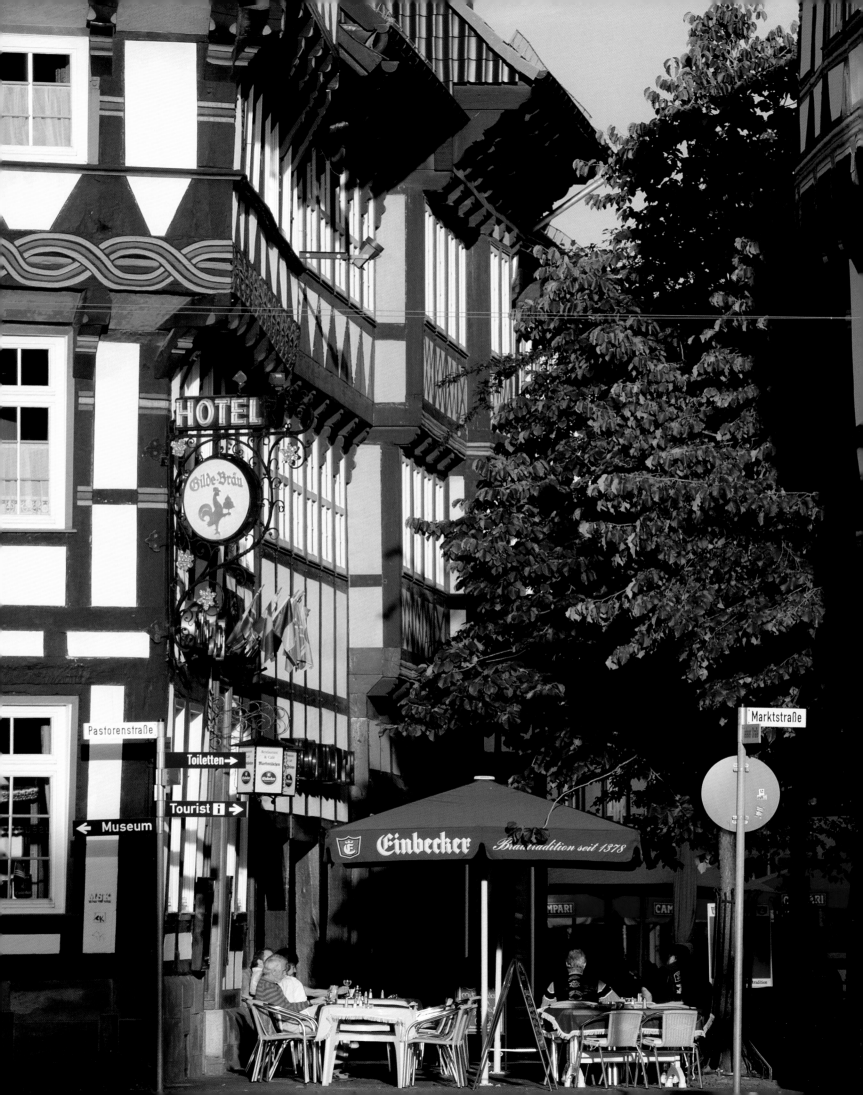

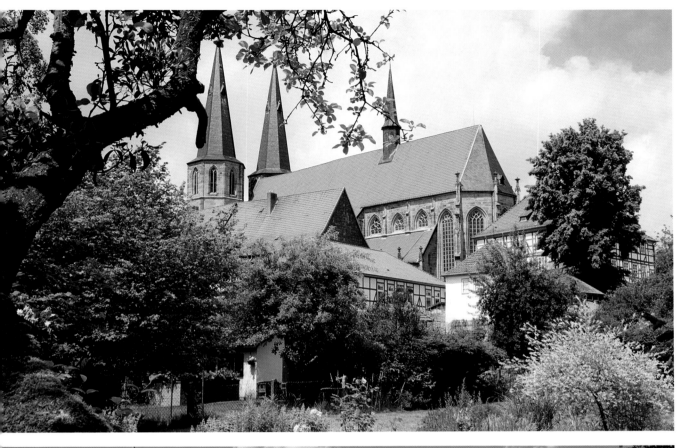

Half-timbered houses on the market square in Bad Gandersheim. The saltwater spa lies tucked in between the Leine and the Harz in the valley of the River Gande.

Medieval Duderstadt boasts around six hundred town houses from various periods, many of them half timbered. The main church is St Cyriakus, also known throughout the region as the Eichsfelder Dom or the cathedral of Eichsfeld.

The traditional brewery town of Einbeck is also famous for its late medieval, half-timbered buildings. The Altes Rathaus or old town hall dates back to 1550–1556, with its three turrets added in 1593.

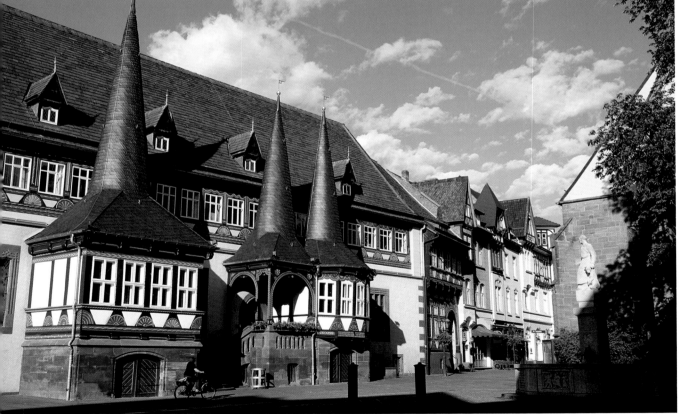

Index

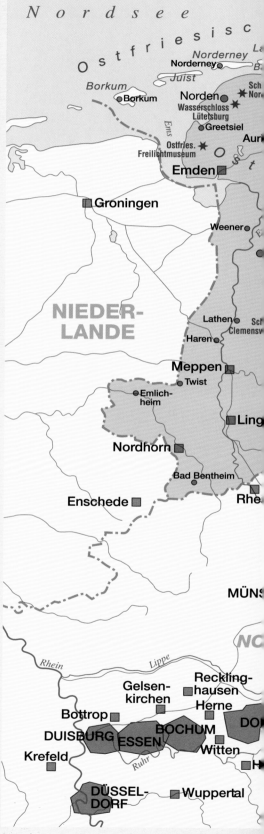

seln
og Wangerooge

Elbe

Brunsbüttel · Itzehoe □ · SCHLESWIG-HOLSTEIN · LÜBECK · Wismar □

Cuxhaven ■

Otterndorf · Naturraum Niederelbe · Elmshorn □ · Norderstedt · Schwerin □

· Carolinensiel

Weser · Bad Bederkesa · Drochtersen □ · Wedel □ · Stade □ · HAMBURG · MECKLENBURG-VORPOMMERN

Nordsee Tropenpark · BREMER-HAVEN · Reinbek · Geesthacht · Lauenburg

Jever · Wilhelms-haven · Norden-ham · Bremervörde · Buxtehude · Wildpark Schwarze Berge · Seevetal · Freilicht-museum · Winsen · Schiffs-hebewerk · Ludwigslust

Schloss Gödens · Jade-busen · NIEDER- · Zeven · Sittensen · Tostedt · Wildpark Lüneburger Heide · Egestorf · Lüneburg · Waldmuseum · Göhrde

Zetel · Varel · Brake · BREMEN · Osterholz-Scharmbeck · Freilichtmuseum Meyerhof · Wildpark Lauenbrück · Schnever-dingen · Amelinghausen · Bienen-büttel · Lüneburger

Westerstede · Schwane-wede · Rotenburg · Heidepark Soltau · Wacholder-paradies · Wendland · Dannen-berg

Bad ...schenahn · OLDENBURG · BREMEN · Otters-berg · Vissel-hövede · Soltau · Munster · Klintmühle · Uelzen · Freilicht-museum · Wittenberge

Delmen-horst · Weyhe · Achim · Verden · Vogelpark · Bad Falling-bostel · Heide · Landwirtschaftsmuseum Lüneburger Heide · Lüchow · Salzwedel

Garrel · Wildes-hausen · Syke · Freizeitpark Verden · Walsrode · Bergen · Hermanns-burg

...ppen-burg · Twistringen · Vechta · Bassum · Bruchhausen-Vilsen · Serengeti Safaripark Hodenhagen · Gedenkstätte Bergen-Belsen · Kloster Hankenbüttel · Wittingen

...ken-...rück · Damme · Lohne · Sulingen · Nienburg · Winsen · Celle · Wahrenholz · Stendal □

...rück · Diepholz · Steyerberg · Deutsches Erdölmuseum · Aller · Gardelegen

Damme · Dümmer Museum · Weser · Festung Wilhelmstein · Steinhuder Meer · Neustadt a. Rübenberge · Burgwedel · Erse-Park- Uetze · Gifhorn · SACHSEN-ANHALT

...er Lage · Archäolog. Museumspark · Rehburg-Loccum · Dinosaurierpark Münchehagen · Garbsen · Langen-hagen · Burgdorf · Wolfsburg

...sche · Bohmte · Wunstorf · HANNOVER · Lehrte · Braunschweig

...brück □ · Schloss Vittekindsburg · Stadthagen · Barsing-hausen · Peine · Königs-lutter · Helmstedt · MAGDE-BURG

Georgs-...enhütte · Schloss Ledenburg · Dietrichsburg · Melle · Minden □ · Besucher-bergwerk · Sarstedt · Salzgitter · Wolfen-büttel · Gedenkstätte Deutsche Teilung

Dissen · Rinteln · Springe · Schloss Marienburg · Hildesheim □ · Schöningen · Heeseberg

...andorf · Herford □ · Weser · Hameln · Elze · Salzgitter-Bad · Ruine Werla

Bielefeld □ · Aerzen · Hämelschenburg · Bad Salz-detfurth · Burg Wohldenberg

Gütersloh □ · Detmold □ · Bad Pyrmont · Alfeld · Goslar · Bergbau-museum · Bad Harzbürg · Halberstadt □

...IN-WESTFALEN · Seesen · Iberger Tropfsteinhöhle · Wernigerode

Holz-minden · Einbeck · Clausthal-Zellerfeld · Brocken ▲1.142m

Hamm · Paderborn □ · Höxter · Waldmuseum · Osterode · Braunlage · Aschers-leben □

Beverungen · Uslar · Solling · Northeim · Herzberg · Einhornhöhle

Weser · Göttingen □ · Duderstadt · Nordhausen □

Hannoversch Münden · Europäisches Brotmuseum

HESSEN · THÜRINGEN

Kassel □

135

Platz Am Sande is the oldest square in Lüneburg. This mermaid weathercock perched above the old coat of arms of the principality of Lüneburg adorns one of the town's brick gables.

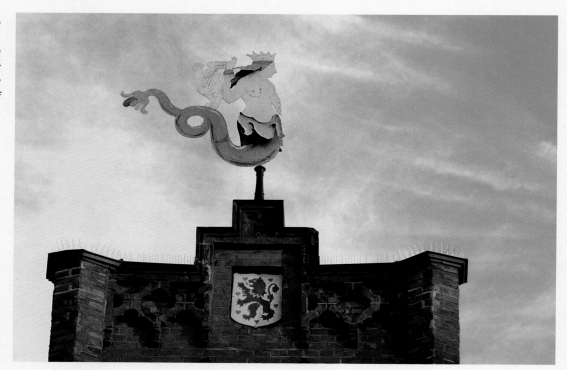

Credits

Design
www.hoyerdesign.de

Map
Fischer Kartografie, Aichach

Translation
Ruth Chitty, Stromberg
www.rapid-com.de

All rights reserved

Printed in Germany
Repro: Artilitho, Lavis-Trento, Italien - www.artilitho.com
Printed/Bound by Offizin Andersen Nexö, Leipzig
© 2009 Verlagshaus Würzburg GmbH & Co. KG
© Photos: Ernst Wrba
© Text: Georg Schwikart

ISBN: 978-3-8003-4019-4

Details of our programme can be found at
www.verlagshaus.com